a comprehensive guide to digital landscape photography

AVA Publishing SA
Switzerland

Sterling Publishing Co., Inc.
New York

Published by AVA Publishing SA
rue du Bugnon 7
CH-1299 Crans-près-Céligny
Switzerland
Tel: +41 786 005 109
Email: enquiries@avabooks.ch

Distributed by Thames and Hudson (ex-North America)
181a High Holborn
London WC1V 7QX
United Kingdom
Tel: +44 20 7845 5000
Fax: +44 20 7845 5050
Email: sales@thameshudson.co.uk
www.thamesandhudson.com

Distributed by Sterling Publishing Co., Inc. in USA
387 Park Avenue South
New York, NY 10016-8810
Tel: +1 212 532 7160
Fax: +1 212 213 2495
www.sterlingpub.com

in Canada
Sterling Publishing
c/o Canadian Manda Group
One Atlantic Avenue, Suite 105
Toronto, Ontario M6K 3E7

English Language Support Office
AVA Publishing (UK) Ltd.
Tel: +44 1903 204 455
Email: enquiries@avabooks.co.uk

ISBN 2-88479-010-1

10 9 8 7 6 5 4 3 2 1

Creative direction and co-ordination: Kate Stephens
Design by Bruce Aiken

Production and separations by
AVA Book Production Pte. Ltd., Singapore
Tel: +65 6334 8173
Fax: +65 6334 0752
Email: production@avabooks.com.sg

a comprehensive guide to digital landscape photography

john clements

contents

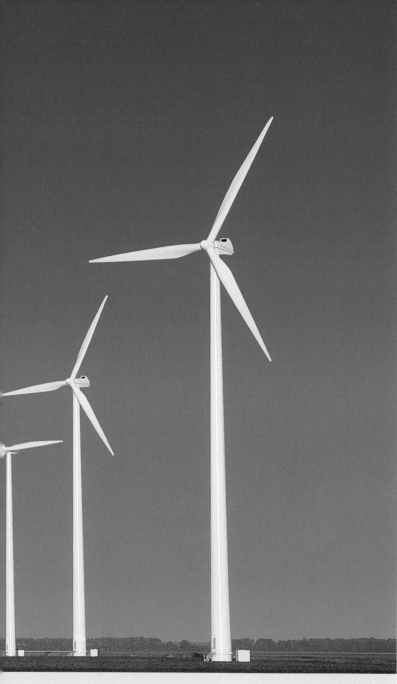

introduction

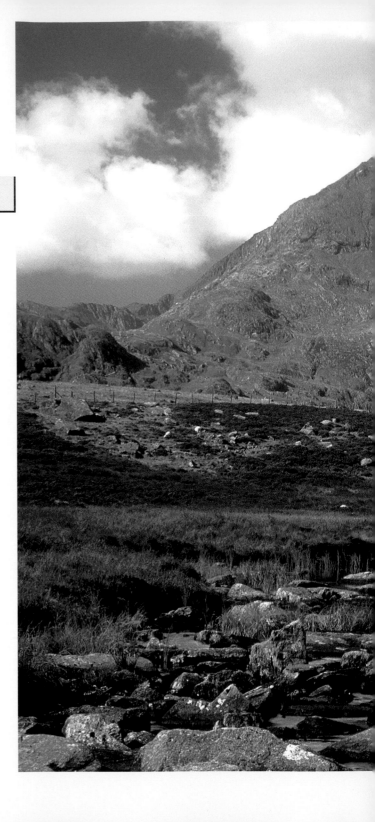

As a species we have always been linked to and drawn to the landscape. Appreciation has replaced the fear that our ancestors felt, but even then, they still took time and pleasure in painting their surroundings and way of life on cave walls for instance.

But with the advent of conventional photography a realism like never before became possible. Some through filtration, darkroom manipulation or even as simple a choice as film type, have been happy to 'create' their own interpretation of the natural world. But no one until they embrace digital photography has the maximum potential for controlling and shaping their work. Put simply, there has never been a better time to be a photographer, be that a professional or enthusiast.

Some still shoot film and 'digitise' images via a scanner rather than 'capture' their work with a digital camera. The purpose of this book is to explore all of these exciting possibilities by looking at what has already been done, how it enhances traditional methods, and suggesting directions to travel with this new creative technology.

But, regardless of your level, this book goes further. After creating the basic image, how do you enhance it to best effect with relatively simple adjustments that are an effective use of your time? And what are the best methods when more than one option presents itself? Numerous ideas, clear technical explanations and some wonderful images, come together in a book suitable for those wanting to explore new ideas and techniques. From the small, nearly incidental type of image, to the expansive vista, the digital world truly is our oyster.

Best wishes and good photography.

John Clements

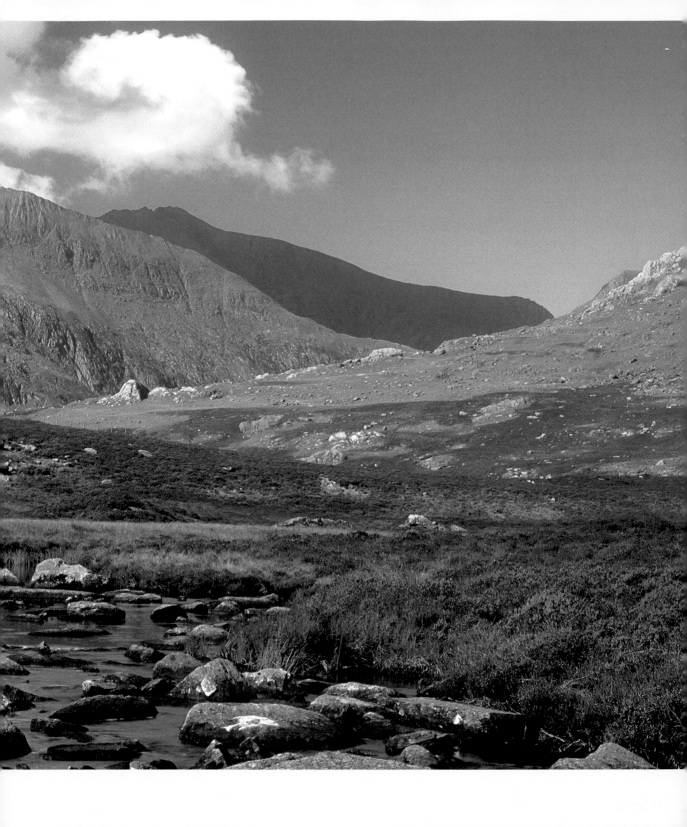

how to get the most from this book

Popular types of landscape imagery are organised into eight chapters. Starting with an overview of ways numerous photographers tackle their subject, each is full of ideas that can be used for other types of landscape picture. A final appendix provides easy reference to terms and location of information in this book.

Each spread is a self-contained explanation of how each image has been created, with helpful quotes and tips to give both a feel of the photographer's thoughts, plus an overview from the author. Grouped with similar subjects, it is possible at a glance to concentrate on your particular interest, while the book as a whole will show how alternative styles and techniques could be applied.

introduction

'I always fill the available storage before I pack up to come home. It costs me nothing to do so.'

simple imaging

If you crop in camera and set any exposure compensation needs, this can save a lot of post-production time. This image is typical, needing minimal post capture work.

flow chart

A useful step-by-step outline of the main stages the image has gone through from exposure is given by a flow chart. This allows a quick reference to the same or similar points of interest on different spreads. The flow chart also enables the reader at a glance to determine how simple or involved an image was to create.

> digital capture
> polarising filter
> exposure compensation
> clone
> auto contrast
> saturate
> despeckle
> sharpen
> median filter
> ink jet print
> screengrab

44 waterworld

section title

tips

Pointing the reader beyond the specific image they are looking at are tips from the author and photographer.

images

The landscape has fascinated and captivated since before the birth of photography. Today there are countless images to be inspired by, taken by those having quite different needs and approaches. This book reflects this, with pictures from those wanting no more than a traditional look, to those with surreal concepts. From digital to large format film capture and manipulation, no matter your preference, the scope of work shown will have something familiar to your way of working.

screengrabs

Often detailing the exact settings used for important parts of the process, a screengrab makes a quick but instructive visual check to follow the proceedings with.

shoot – enhance – enjoy

Divided first into shoot, the background details up until the moment of capture are explained. The choice of equipment along with any preconceived attraction the photographer had to the subject are revealed, with a little about the location in many instances. Next comes the important enhance section, which develops the image through its stages once in computer, outlining the stunning results the digital photographer can create post capture. Finally, enjoy reveals how the image has been used for personal use or professional fulfilment. Throughout brackets or underlining highlight important points.

on the side of derexposure.

re pixels equals re choice.

periment as much you can.

1/ Original image.
2/ Adjusting saturation.
3/ Applying the median filter to reduce noise in the image.

2 hue/saturation

Edit: Master

Hue: 0
Saturation: +18
Lightness: 0

OK
Cancel
Load...
Save...

☐ Colorize
☑ Preview

3 median filter

OK
Cancel
☑ Preview

100%

Radius: 5 pixels

shoot

Steve Vit took this shot late in the evening during summer in the state of Victoria, Australia, at a place known as The Twelve Apostles [1]. He likes to err on the side of underexposure if not sure what settings should be used, as it is easier to lighten a shot than to burn in highlight details, so -0.5 EV exposure was set. As a guide you should treat digital exposure as you would for a slide film. A circular polariser and a UV filter were also fitted. The twilight and landscape picture options on his compact digital camera were set for automated ease.

enhance

The photographer likes to frame shots according to how he wants them to look, in camera if at all possible, but there is always a little work to do afterwards. The image was auto adjusted for contrast, with a manual increase in saturation level made [2].

The image was despeckled [Filter > Noise > Despeckle] and sharpened. Finally parts of the sky were selected, and a median filter applied [Filter > Noise > Median] [3] with a tolerance of 3 pixels set.

enjoy

This image was used as an entry to a web-based photographic competition. Prints were also made for family and friends and screen-saver packages have been put together for other people.

spread title

the digital mind-set

FISHER GERMAN BIGHT HUMBER THAMES DOVER WIGHT PORTLAND PLYMOUTH BISCAY FINISTERRE SOLE LUNDY

FASTNET IRISH SEA SHANNON ROCKALL MALIN HEBRIDES BAILEY FAIR ISLE FAEROES SOUTHEAST ICELAND

VIKING NORTH UTSIRE SOUTH UTSIRE FORTIES CROMARTY FORTH TYNE DOGGER FISHER GERMAN BIGHT HUMBER

5°37'W

seeing digitally

The way light is captured and converted to an image with a digital camera can be fascinating. While some photographers are happy not to understand the concept, preferring to make judgments on the resulting image, <u>critical and precise work requires at least a grasp of the fundamentals</u>. Reaching the best theoretical quality, means you need to be aware of the benefits and drawbacks of digital capture and getting it right will save time in the long run.

sensor size

The physical size of an imaging sensor is quoted like film in mm. Most film cameras sold – compact or an SLR design – have traditionally used 35mm film with its 24mm (high) and 36mm (wide) frame size. This is a standard to compare a sensor against. If it is the same, it is referred to as full frame.

<u>Full-frame sensors</u> make it possible to record the same image area on a digital camera as a 35mm film camera, which makes it easier to select a particular focal length of lens for a specific effect when you are used to traditional ways of thinking. Particularly working with both media.

But when an imaging sensor is smaller in size – such as with compact or some SLR models – the smaller dimensions use less of the optics angle of view, so if a shot is taken from the same position, act in effect, like a teleconverter or as if the photographer had moved closer into the scene.

focal length

The exact effect is dependent of the precise dimensions of the camera's sensor in relation to full frame, but typically a 1.3–1.7x increase in effect is not unusual. To get back to a similar angle of view, requires an optic with a wider angle of view, in reality a shorter focal length.

Those who prefer medium format film cameras for their technical quality can also use a digital capture back for improved digital detail. The sensor inside is also referred to as an equivalent film image size such as 6x4.5cm.

1/ When an imaging sensor is the same size as a 35mm film frame, approximately 24x36mm, it is called full frame.

2/ Conceptual diagram comparing a full-frame sensor size to one that is smaller.

3/ What focal length do you need to equal a lens's full-frame angle of view?

4/ With a full-frame sensor this is a 3:2 ratio. Some photographers prefer a different ratio of 3:1 for their landscape work or even greater.

Many medium format film cameras also accept high quality digital capture backs producing large file sizes. Some need to be 'tethered' to a laptop to download images while shooting.

3 | focal length equivalents

35mm focal length	full-frame angle of view	1.5x sensor equivalent focal length
14mm	114°	21mm
17mm	104°	25.5mm
20mm	94°	30mm
24mm	84°	36mm
28mm	74°	42mm
50mm	46°	75mm
85mm	28°	127.7mm
135mm	18°	202.5mm
200mm	12°	300mm
300mm	8°	450mm
500mm	5°	750mm

2 | sensor size

digital sensor

35mm film frame

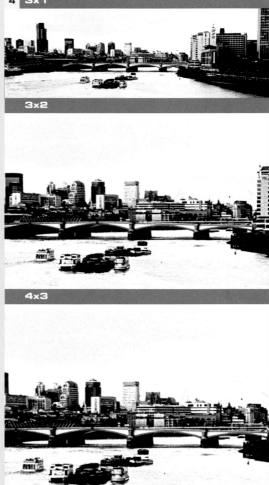

4 3x1

3x2

4x3

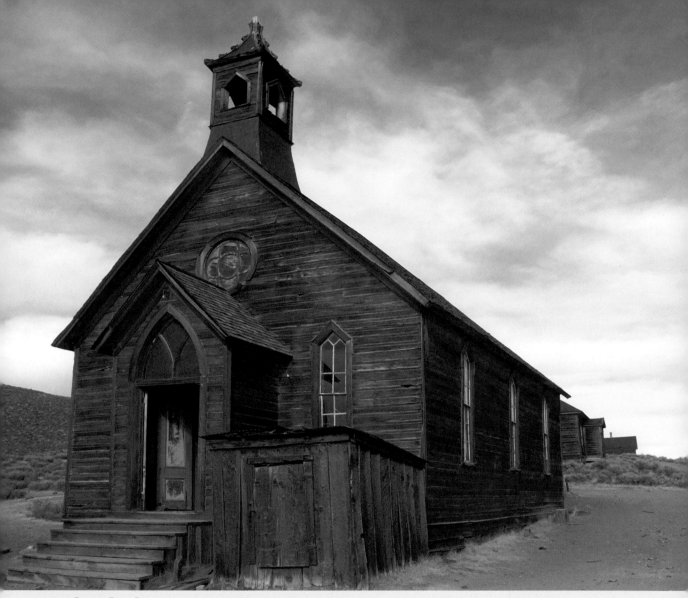

optimising capture

- > **RAW** data capture
- > **JPEG** conversion
- > levels adjustment
- > **USM**
- > photoshop
- > cloning
- > crop
- > perspective crop adjustment
- > ink jet print

No matter how well we make it – with the best materials and design at the time – the landscape always endures over that which is man-made. This image was captured on a professional level digital **SLR** by **Ron Reznick**. It is a fine example by a photographer who firmly believes that digital capture and its dedicated software can create high technical quality.

! Make the histogram your friend, learn how to read and work with it. This is essential for optimum acquisition and processing.

! Expose for the highlights, process for the shadows and mid-tones. This will preserve the maximum dynamic range.

shoot

Bodie is a ghost town in the High Sierras, northeast of Mono Lake in the United States. It was a mining town, but when the mines dried up so did the town. A wide angle 17–35mm f/2.8 lens was used fitted to a digital camera using a smaller than full-frame chip. Therefore the shot was captured with the equivalent angle of view of a 25mm lens on a 35mm camera. The photographer tried to extract and then keep maximum quality. First by saving the shot using RAW data format and in 12-bit colour giving a 7.5Mb file. The image was captured with 2000x1312 pixel dimensions, after the white balance was set manually for sunlight (5200K). The camera's histogram feature was critically analysed to know that the exposure had been set for the highlights, avoiding overexposure and lost detail in this area.

enhance

With his camera's external manipulation software, RAW data was processed and turned into a 'Fine' JPEG (lowest compression) file. Levels adjustment and a mild USM (unsharp mask) were added. After importing into Photoshop, the cloning tool was utilised to overcome dust spots present on the camera's sensor at capture, then a small crop (2) and copyright details were introduced. A final touch was to straighten the building with a perspective adjustment (3).

2 ▢ crop tool

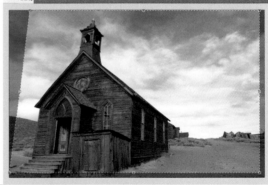

3 ▢ perspective crop

Bodie Church — © 2001 R...

1

1/ Original exposure, 200 ISO, 17mm focal length, 1/250sec at f/11.

2/ The image was first cropped with the crop tool in Photoshop.

3/ The crop tool was used for its perspective control feature.

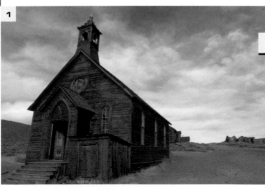

enjoy

This image has taken residence in the photographer's portfolio. Generally prints are made on matte heavyweight paper, using an A3 ink jet printer. Occasionally a large-format ink jet printer outputs the photographer's work on to matte, watercolour or canvas materials.

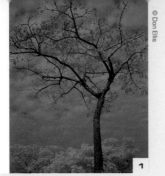
© Don Ellis

1

'Photography shows us a view of the world. Infrared photography shows us a view that we can't normally see, and it's intriguing, often compelling.'

new life in old technique

There have been many processes and techniques used by photographers that may be considered specialist by many. Infrared (IR) photography creeps into that category. But it is easier with digital capture than many realise as we shall see throughout this book. Infrared photography can look slightly surreal, but the important word is slightly. Scenes are immediately recognisable but altered often for the better.

> digital capture
> RAW data
> TIFF file
> photoshop
> set black/white points
> sharpen
> ink jet print
> web

shoot

Don Ellis carries a camera virtually everywhere. As IR photography requires the use of filters that transmit light in this, and or the 'near' visible spectrum only, so the amount of illumination is reduced. Consequently, this resulted in 1/10sec at f/2, (-1/3 EV compensation) exposure with 50 ISO sensitivity set. The camera was a high quality digital compact, with a lens the equivalent of a 34mm in 35mm terms. He saw the three elements together – hedge, tree and clouds – all with distinct textures that work well collectively. The camera was tripod-mounted.

enhance

The photographer keeps things simple post processing; conversion from RAW data, cropping, setting the black and or white points and sharpening, with occasional increase in saturation. White balance can be an issue with IR photography, but by setting the white and black points [2/3] in Photoshop after converting the file from RAW into a TIFF file, it has been found to aid the 'false colour' sought. This has resulted in the pleasing 'rosy' tone seen here. An alternative route used is to set a custom white balance in a program like BreezeBrowser (www.breezesys.com), which lessens the false colour effect, and while this gave a more natural effect with less colour cast, it had less impact with this shot. Auto curves and USM [5] were final touches.

enjoy

There are five options for printing effect that Don has developed for his infrared images. These are; false colour (because the filter used retains some colour), as a greyscale image, a duotone, a tritone or finally a quadtone. With 'Cotton-Wool Clouds' false colour was found to be pleasantly soft and appealing. Prints have been made on to matte photo-quality inkjet paper. This image is resident on the web at the following address; www.kleptography.com.

Channel: RGB

Input Levels: 0 | 1.00 | 255

OK
Cancel
Load...
Save...
Auto
Options...

Output Levels: 0 | 255

☑ Preview

Channel: RGB

OK
Cancel
Load...
Save...
Smooth
Auto

☑ Preview

Input: 37
Output: 26

1/ Original image.

2/3 With the aid of the eye dropper tools and levels adjustment, the black and white points can be set.

4/ Auto curves corrects the final image colour and saturation.

5/ Unsharp mask as it should be is used last.

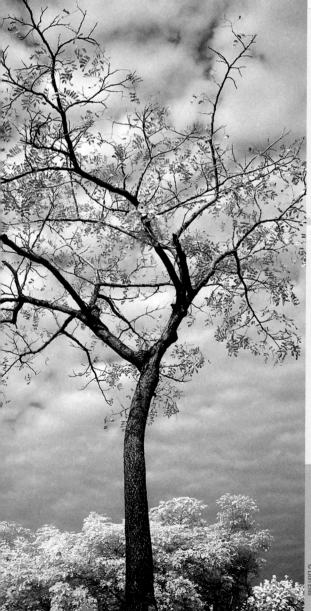

OK
Cancel
☑ Preview

+ 100% −

Amount: 120 %

Radius: 5 pixels

Threshold: 0 levels

film to digital

Film plays a pivotal role for the landscape photographer alongside digital capture. But quality of a scan can make or break the work. Many scanners have software and hardware to make the job as easy as possible. There are some straightforward steps to take to get an image into digital domain.

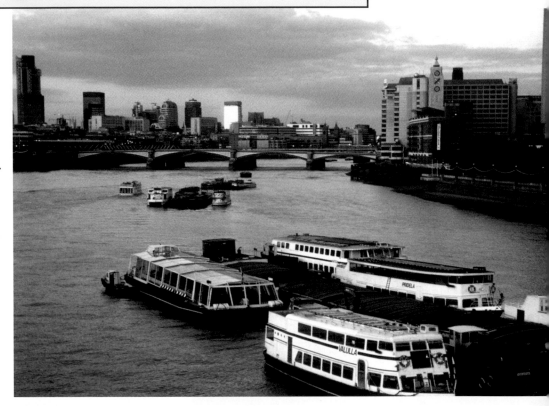

scan

Getting the best result means setting the dpi (dots per inch) or target file size with the end use in mind. Too much detail creates large files, eating up storage space, taking time to scan, while too little and image quality suffers. It is also generally best to scan film rather than prints for quality.

enhance

In the scanning software it is possible to adjust the image in numerous ways. From dust detection and correction, to controlling the dynamic range and mid-tones, the landscape photographer often has to use all of a scanner's capabilities to get the most from a film image. The best scanners are calibrated to get the optimum colour reproduction. Supplied with an IT8 test slide or equivalent [2], a 'colour patch' is scanned and compared with pre-programmed values for the colours it should be detecting. The difference between the two is used to correct data after a scan.

1

Q-60E3 Target for KODAK EKTACHROME
Professional Films

IT8.7/1-1993
2000:05

2

Density Histogram:

☑ Preview ☑ Thumbnails

Custom...

⦿ Keep Color Balance
◯ Adjust Color Balance

Channel: All

Density:

2.4820 D ☐ Auto 0.4218 D

Default | Revert | Add To Menu... | Cancel | OK | ⑦

enjoy

If you scan an image in RGB it will be smaller than if that same image is scanned as a CMYK original because of the extra black (k) channel needed for a full colour image. Likewise, in greyscale the size is smaller as no colour detail is kept, and scanning this way saves time and size.

! Detecting dust and scratches and ignoring them, replacing the colour data in those areas by interpolation from surrounding pixels saves time 're-spotting'. While many consider automatic dust and scratch restoration standard practice, a slight softening may be detected. Contrast and sharpening is therefore beneficial afterwards.

! If corrective software for dust and scratched film is not for you, consider using tools like the healing brush in Photoshop. This not only clones an area, but maintains tonal balance and luminosity. It is quicker to use than the traditional cloning tool.

! If film scanning is not for you or time is short, it is possible to copy your 35mm film originals direct to a digital camera. Many 'compact' models have a suitable adaptor. But, ultimate quality is still best from a scanner.

☑ Preview ☑ Thumbnails

Custom...

Method: Curve

Channel: Master

Input: 50005
Output: 9386
Zoom: 100%

Load...
Save...

Default | Revert | Add To Menu... | Cancel | OK | ⑦

1/ A dedicated film scanner is best for small and medium format originals.

2/ IT8 test chart.

3/ Using a histogram within Microtek's ScanWizard Pro TX software to control the dynamic range.

4/ Image correction via a tone curve adjustment is a very flexible control.

5/ Some digital cameras can 'copy' 35mm film originals via an adaptor.

5

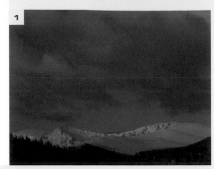

'It saddened me to have to crop most of the sky, but the balance of positive space (the mountainous third), negative space (the black foreground and tree line), and mixed space (sky) really works.'

big reproduction

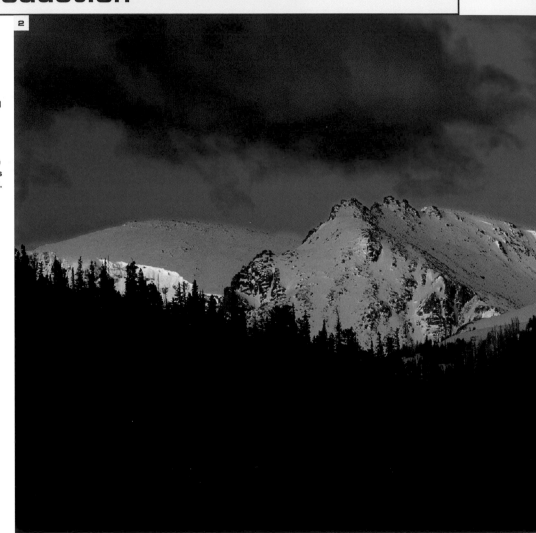

At the 'top end' of photography, digital imaging faces its most demanding test. But by combining the strengths of traditional film photography with careful and creative digital manipulation, ever more stunning imagery results. It allows the photographer to be more productive when it comes to selling his or her work.

> 5x4inch film capture

> scan

> polacolor insight software

> curves

> scan

> photoshop

> re-size

> dust removal

> curves

> clone

> canvas size

> background colour

> canvas size

> rulers

> crop

> hue/saturation

> USM

> print

> web

> cd

shoot

The original was shot on 5x4inch film by Bob Reed. The panoramic slice, 'Dawn Glow Mt Evans' was noted as a possibility while shooting. It was the clouds that made the scene for him – hues of orange, red, purple and blue – so much so, that the bottom of the composition was just below the tree line. As for the shooting conditions; how does 7am, and around -20 degrees sound?

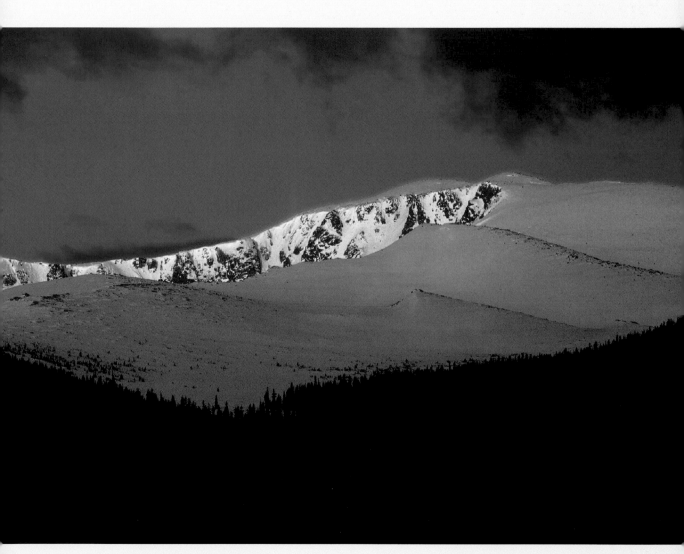

1/ Original image shot on 5x4inch film.

2/ The final image, only possible due to digital manipulation.

> 'Photoshop allows me a powerful tool (non-proportional re-size) with which I can use more or less than the 2" height from the chrome, and make it fit the desired print area.'

3 crop and curves

enhance

The full 5x4inch image was scanned at 2000 dpi making a 192Mb, 24-bit TIFF file. But as mentioned, the most marketable format was perceived as being a 5x2inch panorama crop, resulting in around a 96Mb file. A final scan at the latter size was made after the scanner's software was used to increase contrast via its curves control (3). The image was then re-sized to exactly the desired proportions in Photoshop. Dust and mechanical damage was then removed using the dust and scratches filter [Filter > Noise > Dust & Scratches]. First the sky area was selected and contracted by six pixels and feathered by two, to avoid a blurring of the mountain tops (4). The mountain area was cleaned up with the cloning tool.

Using the 'master' RGB green curve alone, part of the lower section of the image was reduced to black, reading as zero levels of RGB. The brightest highlight in the top right was raised to a reading of R 255, G 170 and B 110 giving near red upper mid-tones (5). Now the lower right foreground needed attention as there was still some distracting detail. This was reduced to black matching the rest of the foreground by cloning from that area (6). Bob found the scene a little top heavy still, so using the often rewarding 'rule of

thirds' as his guide, he decided to extend this shadow area. Selecting black as his background colour, he added to the canvas size [Image > Adjust > Canvas Size] with 3" in height above and below the image (7). By displaying rulers [View > Rulers], the image was cropped back to the desired size (8).

Final touches were to increase the highlights without losing the soft day breaking light on them.

4 dust and scratches

OK
Can
☑ Prev

100%

Radius: 4 pixels

Threshold: 20 levels

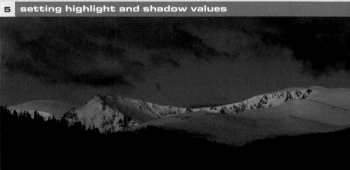

5 setting highlight and shadow values

The brightest areas along the upper ridge were selected with hue/saturation [Image > Adjust > Hue/Saturation] lightening the yellows and saturating subtly the greens (9). Lastly USM was applied with final 'tweaks' made while proofing to get the colour output right on different printers.

Underestimating the number of image elements one can make use of once back in the digital studio is foolish.'

6 cloning tool

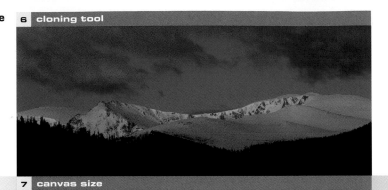

7 canvas size

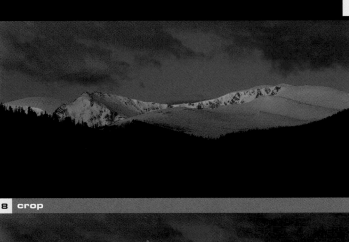

3/ After cropping to roughly the desired size, contrast was raised using curves in the scanning software.

4/ Mechanical damage and dust was removed via the dust and scratches filter.

5/ With the master RGB and individual curve modification, highlight and shadow detail was adjusted to the desired values.

6/ Using the cloning tool, the lower right was reduced to black by matching the tone on the lower left.

7/ By adjusting canvas size the foreground could be extended.

8/ A crop took the image back to the desired size.

9/ The hue and saturation levels were modified before adding USM as the last stage.

The 5x2inch image is printed as 20x8 and 30x12inch ink jet prints, and also on to silver halide paper. It was finally archived to CD. But, one client wanted a 72x30inch print, so about five hours of very selective de-dusting, reduced pixellisation and grain, without losing texture in the snow-covered areas was undertaken to allow such a reproduction to be reached, again ending as a silver halide print. The ink jet images are mounted in a dry mount press with a protective UV (ultraviolet) Lustre print guard for maximising stability and physical protection.

8 crop

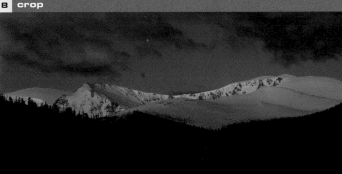

9 hue/saturation

Edit: Yellows

Hue: 0

Saturation: 0

Lightness: 0

OK
Cancel
Load...
Save...

15°/45° 75°\105°

☐ Colorize
☑ Preview

file formats

shoot

No matter how the image is captured – by digital camera or film then scanned – it ends up as a digital data. This information can be saved in various forms each with its advantages and drawbacks. The best one to use, depends on your intentions and may change throughout the workflow.

From the moment image data is captured by a digital camera, it exists in what we refer to as a RAW data. It is just that, a collection of values still awaiting processing for its final colour or greyscale qualities and image sharpening. But where do you go from here? Do you let a camera do all that is necessary so the out-of-camera files are ready for use, or will you prefer to use appropriate software and take control? As images are moved and used, what are the best ways of doing so?

Advanced cameras allow the RAW data to be developed or processed in dedicated software the manufacturer provides. Ultimately this has the maximum potential for the best image quality and flexibility. But, this can mean quite some time at your computer depending on the number of images and work you do to them. RAW data is lossless so no matter how often you use it, there is no discernible drop in quality. While not the smallest file size, it is not the largest either

until it is processed so uses less storage space. A RAW file must however be converted to a TIFF or JPEG file if more than the manufacturer's software can use it.

Alternatively 'processing' can be carried out in camera saving time. Maximum quality is obtained with a TIFF file (Tagged Image File Format). Information from RAW data is used, and converted into a relatively large file. While it is possible to compress a TIFF this is not common. The downside is the storage space used and time in camera that it takes to 'write'. JPEG (Joint Photographic Experts Group) is a file format that has gained widespread popularity. It compresses or throws away much of the RAW data after capture, keeping enough for us to visualise a normal image. Compression frees storage space, increases capture rates and takes less time to email or upload to the web. Technically, however, this is at a minimum quality threshold.

enhance

As soon as you re-save a JPEG file you lose even more data as compression takes place each time. With numerous cycles a noticeable loss of image quality is seen and the JPEG is thought of as a 'lossy' format. Important for all, but especially the landscape worker is the fact that colour data is the information lost mostly. A TIFF file is established in the world of magazine and book reproduction as the most desirable file format. It can be used without perceptible loss of data. It is the safest way to provide a quality file. One other important file format used by and native to Photoshop is the PSD file. Its major benefit is that it preserves 'layers' which is important for some people's style of working on complicated images. A PSD file should have its layers 'flattened' before passing to a third party, helping to reduce the file size.

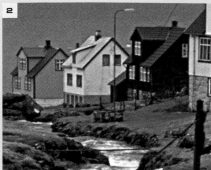

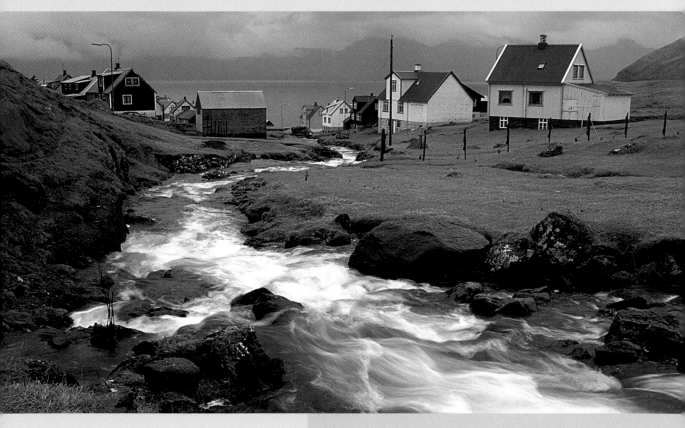

1/ Detail of main image. Maximum quality and long term flexibility comes from RAW data, here converted into an 18Mb TIFF file.

2/ Detail of same image but this time compressed with minimum loss of data to a 3Mb JPEG file.

3/ For viewing on the web a low res JPEG file is fine (0.08Mb), but this detail shows the resultant loss of data and definition.

If you make ink jet prints then a good size JPEG file is often enough. Anything larger and the typical printer's driver software slows down, affecting the printing process. For web-based images even smaller JPEG files can be used and still look sharp on screen. This also protects work from being downloaded and printed at reasonable resolution. For big prints and magazine reproduction a TIFF file is best. It delivers maximum quality in a stable form, and the extra information will reproduce better.

the traditional landscape

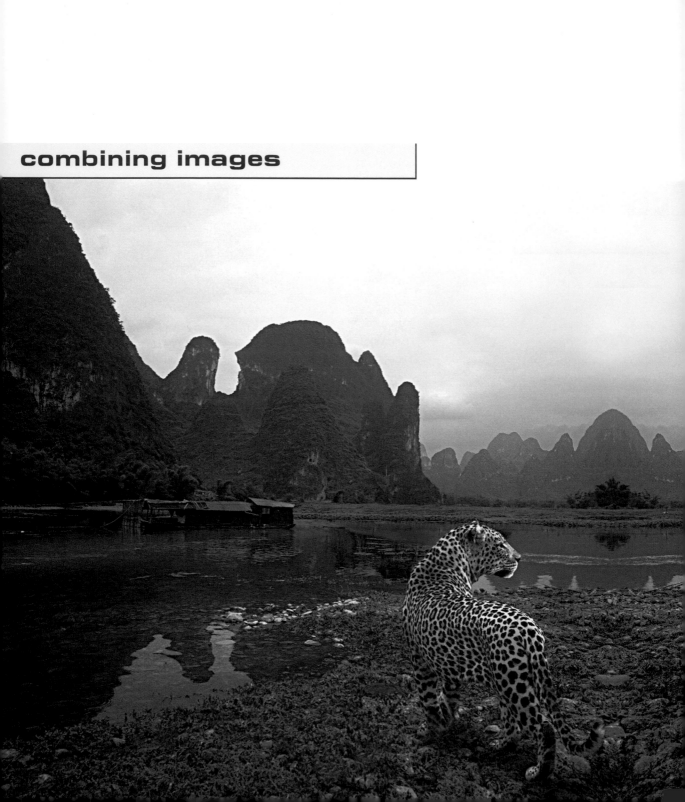

combining images

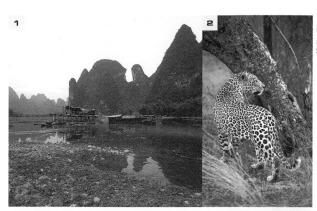

1/ Original landscape shot in China.

2/ Leopard image taken in South Africa.

The scope to produce realistic landscape images has never been greater thanks to digital technology, even when it arises out of images shot in different parts of the world. It is a case of following simple steps to keep a sense of reality.

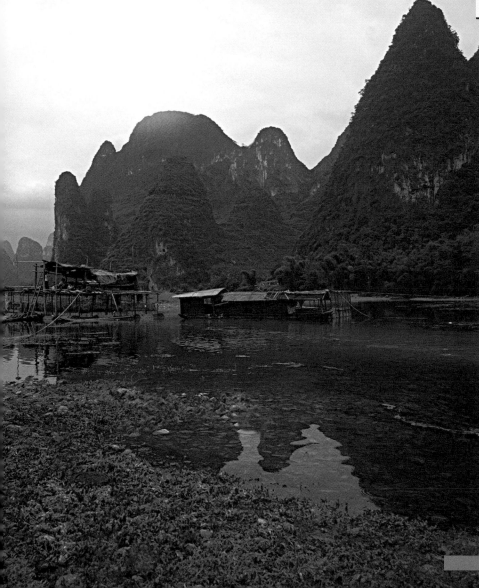

shoot

This image from Maarten Udema is the combination of two film originals. Shot on 6x6cm film [1], the background is an image from China. This has been combined with an image of a South African leopard taken on 35mm [2]. But, there has been plenty of subtle changes made as this image was created to give it a feeling of reality.

> film capture
> scan
> canvas size
> duplicate
> flip
> clone
> re-size
> paste
> burn tool
> enhance sky
> layer
> web
> magazine repro

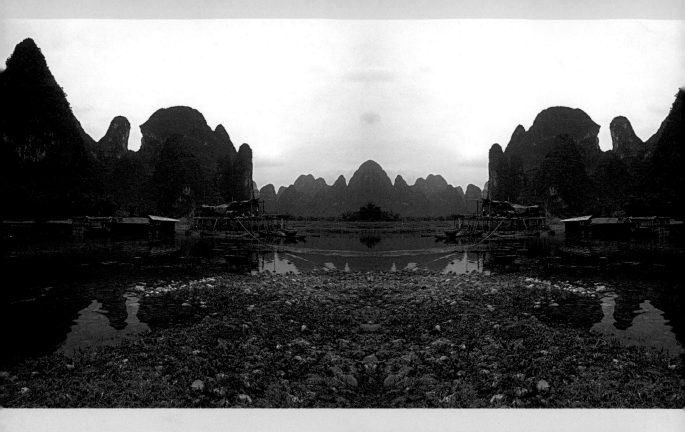

enhance

Step one was to create a panoramic frame, done by doubling the <u>canvas size</u>. Then the China image was duplicated, cut and pasted and flipped horizontally (3). Small changes were made to the mountains, boat, sky and grass to lose some of the symmetry. Then the leopard was re-sized or <u>interpolated</u>, <u>cut</u>, and <u>pasted</u> into the image (4) as a second layer, with a shadow added for reality, by darkening the ground with the <u>burn tool</u> (5). Adding red to the sky (6) took Maarten nearer to his final image. This was accomplished by separating the sky, leopard and water from the background on a <u>separate layer</u>.

4 paste

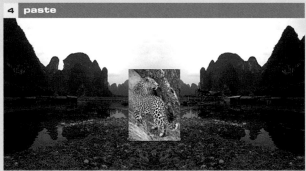

5 burn tool

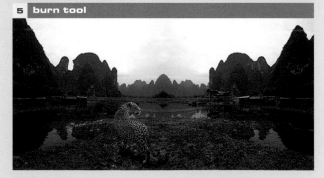

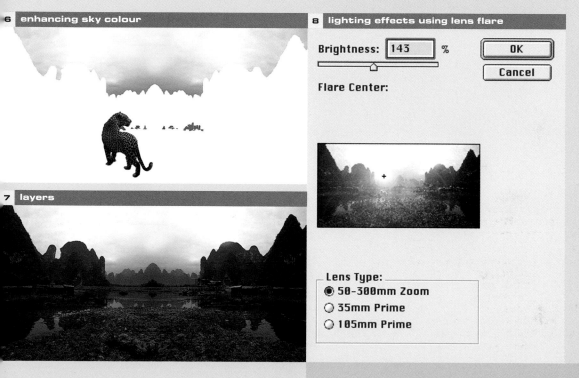

! Maarten also produced a second final image, this time with an artificially created lens flare (8). It is ironic that throughout photography's history, we have tried to avoid such a thing, but with modern imaging in this kind of use, it takes on the artistic or even 'reality' role. Lens flare [Filter > Render > Lighting Effects] can be adjusted for its position via a cross hair marker for intensity and width are adjustable on a scale.

6 **enhancing sky colour**

7 **layers**

8 **lighting effects using lens flare**

Brightness: 143 %

OK

Cancel

Flare Center:

Lens Type:
- ◉ 50–300mm Zoom
- ○ 35mm Prime
- ○ 105mm Prime

3/ Doubling the image size.
4/ Pasting the leopard.
5/ Adding the shadow.
6/ Working on the sky.
7/ Combined layers.
8/ Alternative finish.

enjoy

Apart from residing on his own site, this image has been published in photographic magazines.

Sometimes the most exhilarating moments come from capturing an image when the right conditions are there, but only too briefly. It was the case with this shot by Norman Dodds. It echoes an old saying that summarises one of the keys to landscape photography; 'it pays to be patient'. It also demonstrates that a good quality flatbed scanner can still enable prints to become a reasonable source for image manipulation.

'Glencoe isn't a gentle landscape and it's at its best in this kind of weather. It was the sharp contrast of the golden sunlit mountain with the rather bleaker surroundings which attracted me. I remember waiting until the light was right.'

! Always be aware at the point you take a picture of the ways in which it might be enhanced with software.

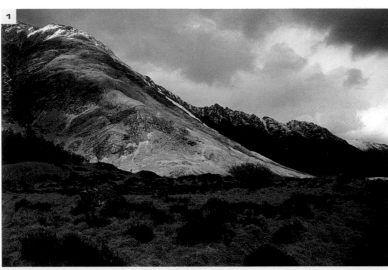

adding digital benefits

shoot

While he now prefers to use digital cameras, this image by Norman Dodds started life on 35mm colour negative film [1]. It was shot on the kind of day the photographer finds most interesting. After a flurry of snow over North West Scotland, Norman was waiting for the first glimpses of sunshine to appear. Using his SLR fitted with a wide angle 28–70mm zoom lens, this image was taken around the 50mm setting at f/5.6. He was happy with the sharp contrast between the golden sunlit mountain top and the bleaker surroundings, but there was work to be done to maximise the effect, as all could not be captured through a single exposure to his liking.

enhance

The resulting 9x7inch print was first scanned to give a resolution of 1024x768 pixels as that is the resolution set on the photographer's 19-inch screen. Corel Photopaint was the destination software, used initially to globally correct the image for brightness, contrast, intensity and colour balance. But there were some minor defects on the original print, so using a clone tool, these were removed.

After masking different areas of the image, further localised adjustments were made to the brightness, contrast, colour balance, saturation and hue [2]. The reason? To maintain detail in the sky, but also to bring out the colour in the sunlit part of the image.

Each mask was created using the magic wand tool which selects areas by colour, with the tolerance level set according to the complexity of the area being worked upon. The actual level was achieved by a degree of trial and error, but in the main, this was relatively straightforward at first, as the areas to be masked were quite distinct. As the mask was built, the tolerance was set to ever smaller levels to achieve a fine join at the edges. That said, the undo function also came in handy! Once the mask was complete, the feather command with a very small feathering modifier (usually 2 on a scale of 0–300) helped to avoid obvious 'joins'.

> 35mm film
> flatbed scanner
> photopaint
> brightness
> contrast
> colour balance
> clone tool
> mask
> brightness
> contrast
> saturation
> hue

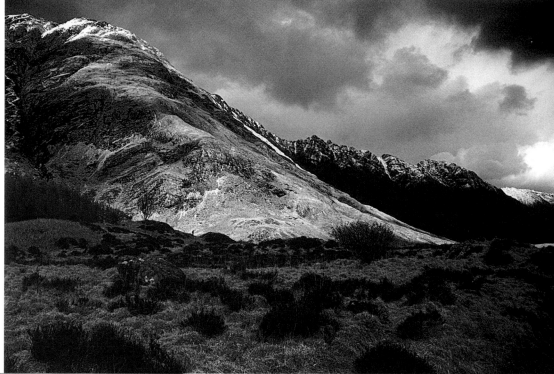

With digital you can take several shots, exposing each for a different area of the composition. The aim is to end up with a correctly exposed sky and correctly exposed landscape. The two (or more) can be superimposed, and adjusted so that the end result is as natural as possible.

1/ Original exposure.

2/ Local enhancement started to work the image towards its final result.

enjoy

As an enthusiastic amateur, it is mostly friends and family that get to see this and similar work. The image has been output via an ink jet printer on to a photo quality paper at up to <u>A4</u> size photo quality gloss and matte finishes. The image looks better on the latter. As far as printer settings go, a profile was downloaded from the internet from which Photopaint sets most parameters, but a <u>300 dpi</u> is always used.

'Glencoe' has been mounted in simple frames, nothing too ornate, with dark card mounts. Likewise, it has been placed on the photographer's website and is used as part of his powerpoint and slide show presentations via an <u>LCD projector</u>. This produces a huge result but it also allows the use of other computer effects such as captions, transitions, wipes, fades and dissolves to be incorporated. ACDSee software makes it possible to retrieve this or any image in a few seconds whenever the image needs revisiting.

getting the basics right

cropping

There are a number of tools and effects that are commonly used. Getting the basics right is the best platform for what comes later.

One of the first things to do in manipulation software is crop to the desired area. The crop tool in Photoshop or similar [1] shows the modified image and the parts to be lost. It works with a simple click and drag action. Use it also to correct lines which are not parallel with its 'perspective' control.

clone tool

The clone tool, also known as the rubber stamp, is often reached for. Dust on film needs removing, less so if scanner software can do a similar job, but it can also be captured on a camera's sensor. The clone tool is easiest to use on similarly toned areas, and when the size of brush is suitably chosen. It is also useful to use when extending the image area. A copy of a selected area is made by pressing the Alt key on a Mac or PC and is then pasted over the desired area by clicking the mouse.

The healing brush or similar is often more important. It will clone from one area to another, but maintains tonality and texture so lighting direction effects are easier to maintain.

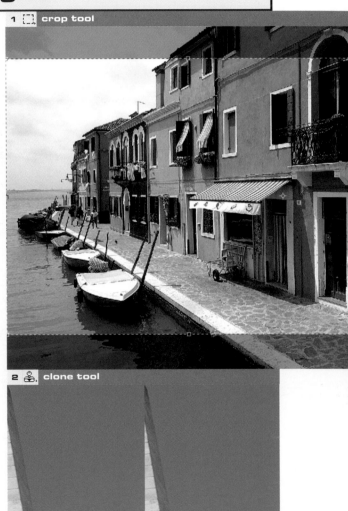

1 ⬚ crop tool

2 ♣ clone tool

Sharpening is usually best done at the end of the creative process.

! If you use digital capture, many cameras allow different degrees of sharpening; normal, high, low or none. If giant prints are your aim, it is often best to set 'none' and sharpen in your post-production software. Experiment, the differences may surprise you.

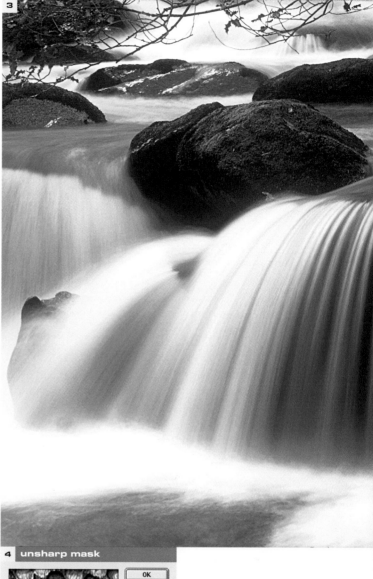

3

unsharp mask

USM or unsharp mask [Filter > Sharpen > Unsharp Mask] [4] is the usual means to increase apparent punch of an image. The effect is variable and ideal for working on the full image or specific areas. The name is derived from traditional darkroom photography with the effect contradictory to its name. Set for its amount (the greater the stronger), threshold (contrast difference between pixels at which the effect works) and radius (how many pixels either side of reference pixels are changed). Making ink jet tests is more realistic than judging the on-screen effect. For enlargements 150–200% amount is often best, with a radius of 1 or 2. Use the threshold value carefully, too much may introduce noise effects. Most enlargements are set between 2 and 20.

1/ The best crop tools can be controlled from various points to get the desired effect.

2/ The rubber stamp or similar is commonly used as here to 'clone' a patch of sky on to another, hiding dust marks from a captured image.

3/ No matter how complex an image becomes, it starts with basic adjustments.

4/ Dialog box of USM; get to know it as virtually every image needs sharpening at some stage in the workflow.

4 unsharp mask

| OK |
| Cancel |
☑ Preview

100%

Amount: 171 %

Radius: 1.0 pixels

Threshold: 0 levels

'The ability to see in realtime infrared is something impossible with "analogue" photography.'

simple infrared imaging

Digital cameras prove especially useful for very specific types of photography, and many for infrared (IR) imaging. When using film, this can require hit and miss experimentation and careful handling. Many (but not all) digital cameras open up this fascinating technique with all the benefits and immediacy of digital capture. Some are better than others depending on how good their IR blocking characteristics are. Frank Lemire shares here his secrets about 'Spiny Tree', which along with a simple software adjustment, keeps things nice and easy but with stunning results.

> digital capture
> on-camera filtration
> auto levels
> cloning
> ink jet print
> web

shoot

This image was taken with a compact digital camera at 200 ISO, 28mm lens (equivalent) and 1/30sec at f/3.5. You will need plenty of light for IR work, as the appropriate IR transmitting filter absorbs lots of it. The one used allows in the tail-end of the visible as well as the infrared spectrum which the camera's CCD is sensitive to be recorded. The compact digital camera had no facility for attaching filters directly, so a wide angle lens adaptor was fitted in turn taking a 72mm size. Bracketed exposures are very useful, so too is the instant play back capability from which you can make judgments on the spot.

enhance

In the computer things were kept simple. Using Photoshop, auto levels [Image > Adjustments > Auto Levels] corrected colour balance, which is where Frank finds a problem with digital cameras and infrared photography. It also adjusted contrast and sharpness. Then a distracting willow tree on the right was removed with the clone tool.

enjoy

The shot was taken as part of a long term project photographing Wards Island not far from Toronto, Canada. The image has been output on to A4 sheets of archival heavyweight matte paper output on an ink jet printer.

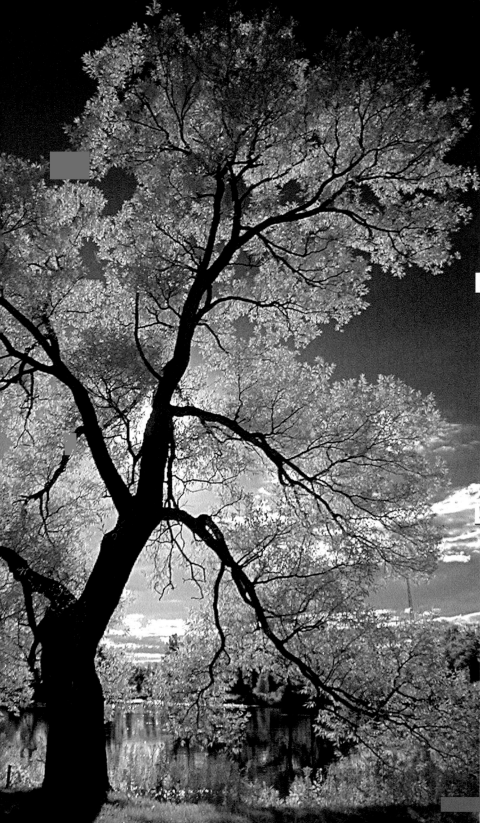

1/ The final image after colour balance was corrected and contrast and sharpness were adjusted.

2/ TV remote for testing infrared sensitivity.

2

! **Is your digital camera suitable for IR photography? A simple test is to trigger a TV remote directly at it in a darkened room. The omitted IR beam of light will be recorded by a camera not featuring a strong IR blocking filter usually placed in front of its sensor.**

! **For straightforward results an 'auto levels' correction or similar often gives a result that is at best spot on, or at least a good place to start before a manual control of 'levels'. But pay attention to any colour adjustment needed afterwards.**

! By decreasing the colour temperature through your camera's manual white balance control, a warmer look is obtained, conversely an increase provides a cooler result. Used subtly, this can help create the right mood in a landscape and may save the need to filter.

correcting a colour cast

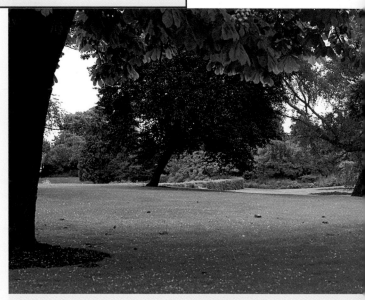

shoot

Countless hours have been spent by photographers using traditional materials, trying to overcome a colour cast in their prints. The digital age has simplified the process and getting the best colour balance is easier and more controllable.

Digital capture makes life easier when it comes to getting the colour balance right. Filtration on a film camera can do the job well, but it can be slow, needs experience, plus a relatively expensive colour temperature meter, and accurate processing for it to work. With auto white balance set, most digital cameras provide a good result quickly, but it is with the manual pre set and measurement capabilities that we get best control. An incorrect white balance introduces a colour cast, and while in small values this may be pleasing – by warming or cooling an image for example – it is to be avoided in extremes. Ultimately, manual white balance is best.

enhance

There is much that can be done in software for white balance correction of a camera or scanned image. Straightforward are features like Photoshop's variations [Image > Adjustments > Variations] [1]. We see a number of options from purely darker and lighter, to subtle colour differences for the image. Clicking on the preferred thumbnail sets this as the 'current pick'. Click 'ok' if you wish the main image to look the same. It's quick and capable, with plenty of versatile parameters that can be set, but it does like any option, need a monitor displaying colours as accurately as possible. Alternatively, colour balance [Image > Adjustments > Colour Balance] [2] allows more manual control. But, if the simplest approach is wanted, the auto colour or similar in Photoshop [Image > Adjustments > Auto Colour] is best.

> photoshop
> image
> adjustments
> colour balance
> auto colour

1

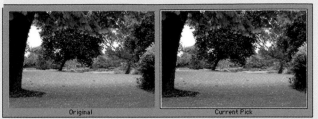

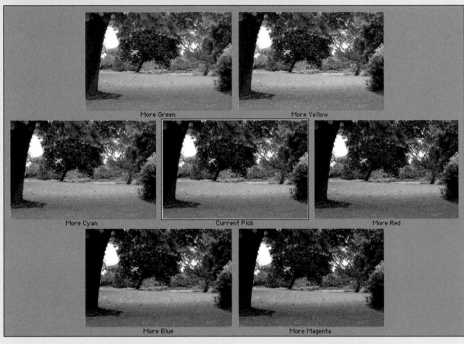

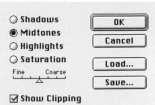

- ○ Shadows
- ● Midtones
- ○ Highlights
- ○ Saturation

Fine — Coarse

☑ Show Clipping

OK
Cancel
Load...
Save...

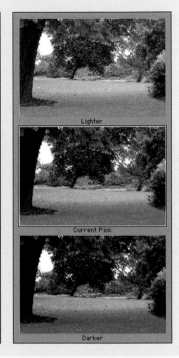

Original
Current Pick

More Green
More Yellow
Lighter

More Cyan
Current Pick
More Red
Current Pick

More Blue
More Magenta
Darker

2 colour balance

Color Balance

Color Levels: +68 0 +2

Cyan ════════════△══ Red
Magenta ═══════△══════ Green
Yellow ══════△═══════ Blue

OK
Cancel

☑ Preview

Tone Balance

○ Shadows ● Midtones ○ Highlights
☑ Preserve Luminosity

1/ The overall colour was wrong, so the auto colour option was the simplest solution.

2/ The colour balance control is easy to use.

enjoy

One of the most useful things we can do when others use our work, is to send a 'matched' print along with the digital file showing things as we feel they should be. This gives those reproducing it something to aim at, even if the image looks different on their system.

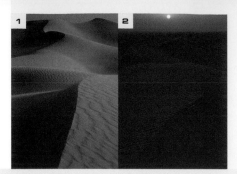

'I have revisited this image twice now in the digital domain; time spent in post-processing, probably 4–5 hours; there was a lot of retouching to do before I was satisfied.'

perfecting the mood

shoot

As photographers we have all been in the situation where a potential shot is nearly, but not quite there. For the landscape worker it is often a weak sky that it falls down to. But it does not have to be that way.

Using a 35mm SLR and 28mm f/2.8 prime lens, Jon Bower took these two original shots. A slow speed and hence fine grained film of 50 ISO, along with an f/11 aperture and fast shutter speed, all combined to give high definition. In addition, the hyper focal distance position gave near-to-far sharpness through maximum depth of field. The first foreground shot was taken at about 16:00 hours [1] and brings out the modelling on the dunes, but the sky was disappointing. A later shot just before sunset [2] had a better skyline but an underexposed landscape.

> 35mm film capture
> scan
> photoshop
> curves
> levels
> cloning
> magic wand
> feathering
> cloning
> duplicate layer
> cut and paste
> flatten image
> cloning
> gaussian blur
> ink jet print
> web
> magazine repro

enhance

The transparencies were scanned at 4000 dpi using a dedicated 35mm film scanner. All post-processing was carried out in Photoshop. The sky from the second image and landscape from the first, were separately optimised using curves and levels, then carefully de-spotted in 'view pixels' mode using the clone tool.

With the help of the magic wand tool, aided by feathering, cloning and low-opacity airbrush work in mask view, the sky in both images was selected. Then the sky from image two was pasted into a duplicate layer of the first image. This multi-layer image was then flattened, and the join examined at pixel level. Further correction was provided by careful cloning at low opacity. Finally, some selective mild smoothing was applied to the sky using gaussian blur to subdue grain.

3 magic wand

4 lasso tool

5 pen tool

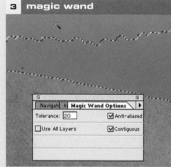

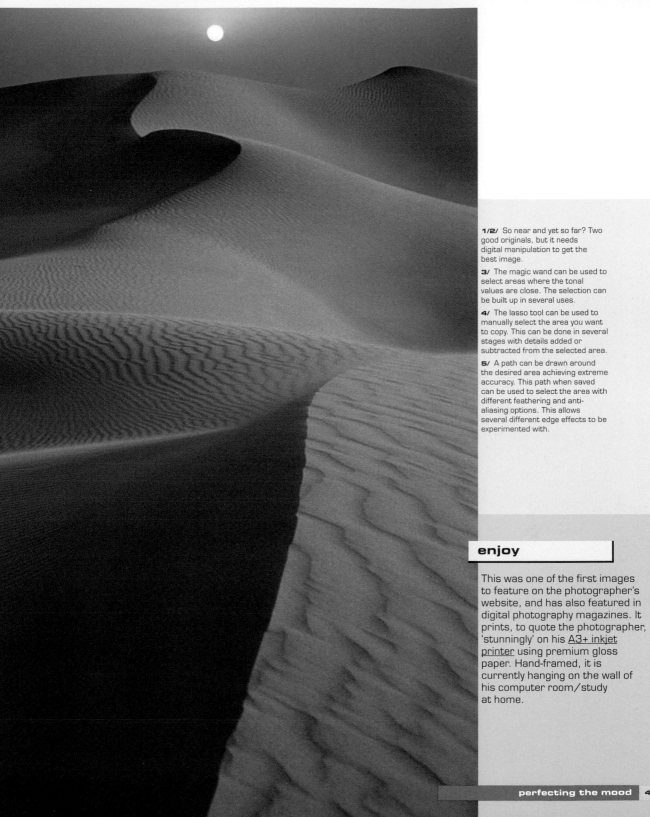

1/2/ So near and yet so far? Two good originals, but it needs digital manipulation to get the best image.

3/ The magic wand can be used to select areas where the tonal values are close. The selection can be built up in several uses.

4/ The lasso tool can be used to manually select the area you want to copy. This can be done in several stages with details added or subtracted from the selected area.

5/ A path can be drawn around the desired area achieving extreme accuracy. This path when saved can be used to select the area with different feathering and anti-aliasing options. This allows several different edge effects to be experimented with.

enjoy

This was one of the first images to feature on the photographer's website, and has also featured in digital photography magazines. It prints, to quote the photographer, 'stunningly' on his <u>A3+ inkjet printer</u> using premium gloss paper. Hand-framed, it is currently hanging on the wall of his computer room/study at home.

waterworld

! Err on the side of underexposure.

! More pixels equals more choice.

! Experiment as much as you can.

simple imaging

If you crop in camera and set any exposure compensation needs, this can save a lot of post-production time. This image is typical, needing minimal post capture work.

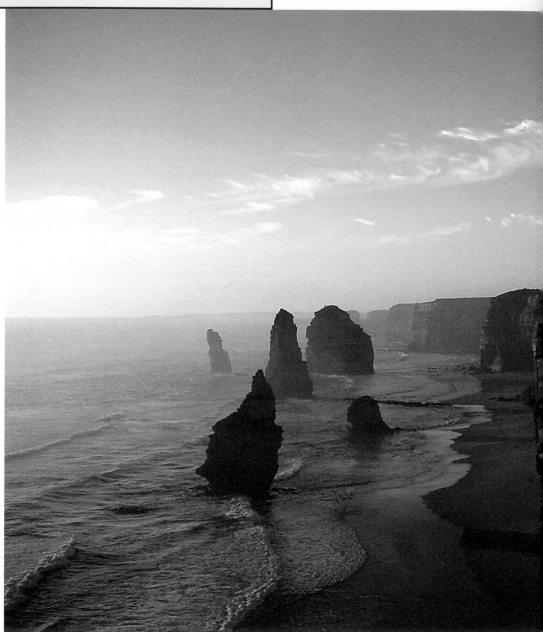

> digital capture

> polarising filter

> exposure compensation

> clone

> auto contrast

> saturate

> despeckle

> sharpen

> median filter

> ink jet print

> screengrab

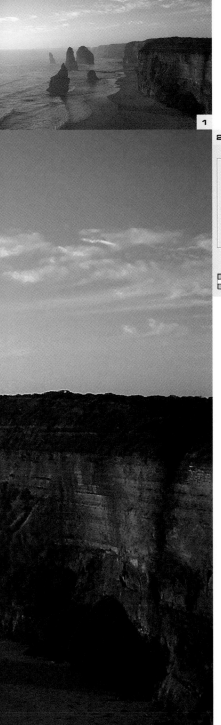

1/ Original image.

2/ Adjusting saturation.

3/ Applying the median filter to reduce noise in the image.

shoot

Steve Vit took this shot late in the evening during summer in the state of Victoria, Australia, at a place known as The Twelve Apostles [1]. He likes to err on the side of underexposure if not sure what settings should be used, as it is easier to lighten a shot than to burn in highlight details, so -0.5 EV exposure was set. As a guide you should treat digital exposure as you would for a slide film. A circular polariser and a UV filter were also fitted. The twilight and landscape picture options on his compact digital camera were set for automated ease.

enhance

The photographer likes to frame shots according to how he wants them to look, in camera if at all possible, but there is always a little work to do afterwards. The image was auto adjusted for contrast, with a manual increase in saturation level made [2].

The image was despeckled [Filter > Noise > Despeckle] and sharpened. Finally parts of the sky were selected, and a median filter applied [Filter > Noise > Median] [3] with a tolerance of 3 pixels set.

enjoy

This image was used as an entry to a web-based photographic competition. Prints were also made for family and friends and screen-saver packages have been put together for other people.

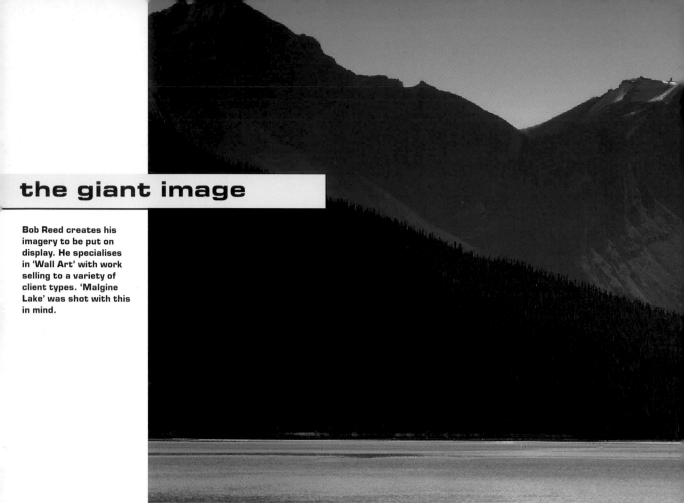

the giant image

Bob Reed creates his imagery to be put on display. He specialises in 'Wall Art' with work selling to a variety of client types. 'Malgine Lake' was shot with this in mind.

> 5x4inch film capture

> scan

> TIFF file

> crop

> select

> mask

> hue/saturation

> ink jet print

> silver halide print

> archive to cd

shoot

A 5x4inch large format camera with slow 50 ISO colour transparency film was used to capture the initial image [1]. The glacier at the other end of the lake was ten miles away. As for lighting, the image was backlit so the shot was into the sun. The 500mm lens was fighting flare and creating quite a monochrome image on film. A pseudo panoramic 5x2inch format was envisaged at the time [2].

enhance

The 5x4 original was scanned at 2000 dpi creating a 192Mb file, saved in the TIFF format as a 24-bit image. The beauty in the shot was its simplicity, the sense of infinite space, and the subtle range of blue hues created by the receding mountain masses. But these did not show up as distinctly separate so there was some work to put in. They were selected, as masks, then patient hours were spent 'tweaking' the contrast and colour via Photoshop's hue/saturation [Image > Adjustments > Hue/Saturation] control [3/4].

In all, eight separate areas were worked on providing an expanded depth. Ink jet prints tested the progress. But this was worthwhile as the enlargement size reproduces without noticeable grain or pixellisation, and with a beautiful tonality. An aspect the photographer is proud of is that there is no evidence of manipulation at the edges of the selected areas due to the fine feathering value used.

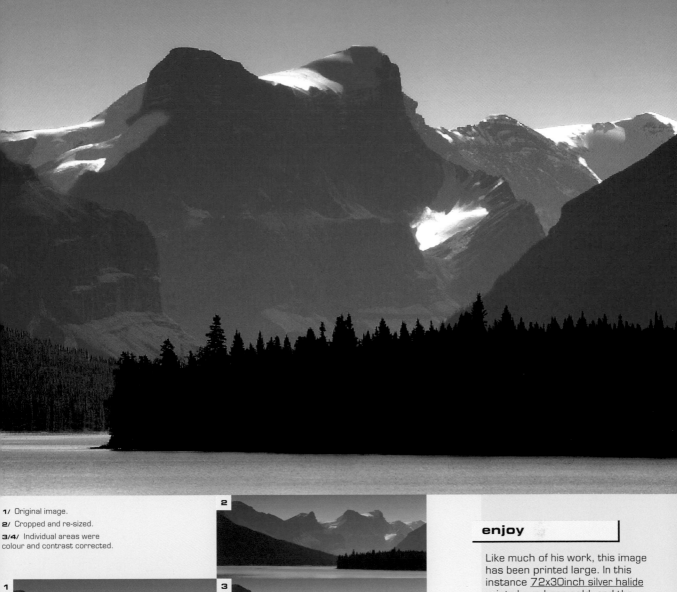

1/ Original image.

2/ Cropped and re-sized.

3/4/ Individual areas were colour and contrast corrected.

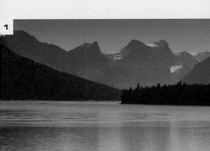

enjoy

Like much of his work, this image has been printed large. In this instance 72x30inch silver halide prints have been sold, and the photographer feels it would easily go as large as 120x48inch if required.

'I have remade many of my earlier images digitally with dramatic improvement, including this shot. It helps when producing giant print sizes.'

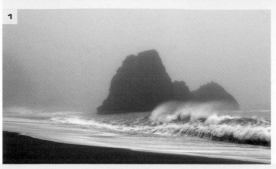

'I took half a dozen shots with different wave patterns. This was the best one. I like the dynamic of the wave and you can feel its strength.'

consistent performance

shoot

Having a set of logical and proven steps enables a digital photographer to get the best quality from capture, ready for post-production.

Henri Lamiraux often visits the Bay Area of Marin County north of San Francisco. It was very overcast and kind of gloomy on the day 'Rodeo Beach' was taken. The photographer finds it a rewarding location for fog – a favourite subject – and critical in giving this image some mystery. Attracted by a big rock just visible through the mist,

combined with the ocean waves and dark sand on the beach, it seemed a nice composition. For capture a pro level digital SLR was used, shot with NEF RAW data (Nikon RAW format) file format. This, like any RAW format gives the best latitude to alter the image in post-production. White balance was set to 'cloudy' and sharpening to 'normal'.

2 camera settings

> digital camera capture

> RAW

> iView multimedia

> nikon capture

> copy

> 16-bit TIFF

> 8-bit TIFF

> levels

> noise reduction plug-in

> cd

> web

> ink jet print

enhance

Henri's working method is methodical. Using iView Multimedia browser to load all the images he discards any that have obvious problems. If needed, the original NEF images are loaded into dedicated software, Nikon Capture, and adjusted for white balance when necessary and any additional minor tweaking. A new copy of the NEF file with the updated settings is saved, then along with other shots, converted to 16-bit TIFF files using the batch processing capabilities. Then comes archiving on to two CDs. One the photographer keeps at home and one at the office. The 16-bit TIFF format was converted again to an 8-bit TIFF in Photoshop because the greater colour depth resulted in a 33Mb file, bigger than the photographer wanted.

Levels were used to reduce a small green colour cast and bump up the contrast. As the shot was taken at a 400 ISO equivalent, there is some visible noise in the shadow area of the larger rock, which was removed by using a Noise Reduction Pro plug-in from www.theimagingfactory.com.

1/ Original image.

2/ Dedicated camera software can offer more than RAW data, colour space or white balance adjustments. Some enable the landscape photographer to overlay a grid, variable in size and colour depending on the subject to aid composition and alignment changes during enhancement.

enjoy

Henri's best images end up on his website (www.realside.com), but some are printed as cards or for display on an A3+ pigment ink jet printer. Adobe GoLive is used to edit his website. When printing or publishing on the web, Henri always uses this master image and will apply final sharpening on a copy of the master image depending on usage (web or print).

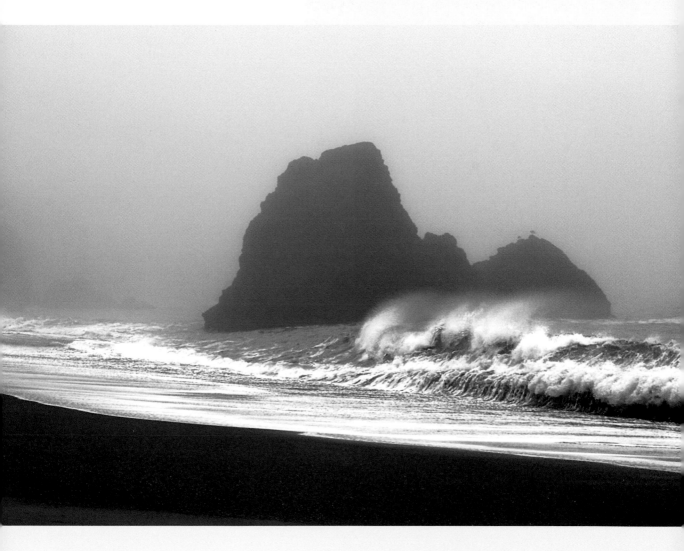

! Have a back-up and archiving strategy.

'Digital capture I find very liberating – no waiting to see what you've shot – and the chance to experiment more when you see what does and doesn't work.'

getting it right in camera

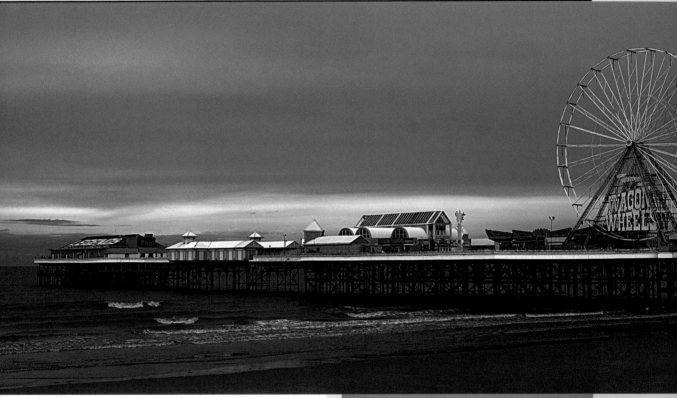

Digital imaging can save an image after it has been taken, or turn a reasonable shot into something more memorable. But it takes time. It is, as it has always been, better to get things right in camera to lessen the post-production time, and maximise the potential quality you have to work with.

1

> digital capture

> histogram

> auto levels

> crop tool

> ink jet print

shoot

Steve Marley has given up shooting film for digital camera capture, taking this shot on a professional quality SLR. But here is one photographer who remains traditional at heart, trying to recreate what he saw, but never falsifying except for enhancing contrast or removing a colour cast. The shot [1] was taken with a 28–70mm f/2.8 zoom lens but as the camera has a less than full-frame sensor, the effective focal length was around 42mm. The camera's 'Fine' JPEG mode gave a small file size with the least compression applied, then levels were adjusted as the photographer is a great believer in using his camera's histogram to check levels on the LCD screen, as well as zooming in to check image sharpness.

enhance

For those who want an easy life they will be pleased to know that this is not untypical of many pieces of work that require little post capture manipulation. In fact, it was only necessary to use auto levels in Photoshop to adjust colour, contrast and sharpness. But do remember that the camera's histogram is utilised to enable accurate exposure in camera, making the software's work easier.

A final and simple touch was added. A crop of the upper and lower parts of the image using the rectangular crop tool gave more of a pseudo panoramic feel which was felt suited to this subject [4].

enjoy

While Steve is commissioned for much of his photography, this is a personal shot that has ended up as a framed print made from an ink jet printer on to premium quality glossy paper. The A4 size image was printed at 300 dpi.

2 levels

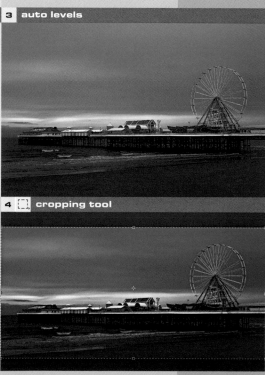

3 auto levels

4 cropping tool

1/ Original shot.

2/3/ Photoshop histogram of the captured image. Auto levels image.

4/ Cropping area.

'I was fascinated by the results. The process was surprisingly simple, and the final image had such a persuasive quality that it stirred some controversies.'

'When I told my friends about what I did to make it look like a reflection, they said it was cheating.'

cut, paste, copy

Cut and paste is one of the simplest techniques not just to undertake, but for creating visually striking images. Add some slightly more advanced but still straightforward touches, and you end up with a winning image.

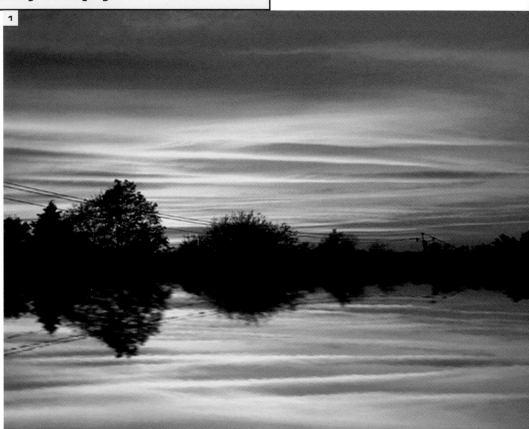

1

> digital capture
> select
> copy
> paste
> new canvas
> flip
> copy
> re-size canvas
> layer
> move
> filter
> distort
> ocean ripple
> flatten
> crop
> web
> ink jet print

shoot

Daniel Lai used a tripod-mounted 2 megapixel camera for this image fitted with an equivalent 28mm focal length lens. Taken from a second floor window, the skyline seemed attractive.

Further inspiration came from images that made use of sunset reflections on lakes or rivers, so he thought this could be one of those by using a simple copy-and-paste approach.

> **!** Adding to or removing parts of the canvas [Image > Canvas Size] in Photoshop increases or decreases the space around an image. Making it bigger enables other elements or extended areas to be added, while a smaller size crops the image.

2 canvas size > centred image

Current Size: 23.9M
Width: 30 cm
Height: 20 cm

[OK]
[Cancel]

New Size: 23.9M
Width: 30 cm ▲▼
Height: 20 cm ▲▼
☐ Relative

Anchor:

enhance

First the whole image was selected [Select > All] then copied [Edit > Copy]. This was pasted on to a new canvas [File > New > Edit > Paste]. To look right, the image was flipped vertically [Image > Rotate Canvas > Flip Vertical], selected and copied [Select All > Copy].

Working on the original, image height was increased by 200% [Image > Canvas Re-size] then a new layer introduced [Layer > New > Background]. The move tool dragged the image to the top, then layer 1 to the bottom of the canvas, and adjusted to the desired position.

Final touches were to apply ocean ripple effect [Filter > Distort > Ocean Ripple], flatten the image [Layer > Flatten Image] and crop. This was to lose some of the water for effect, so a third of the image was cropped out and image size adjusted.

3 canvas size > image at bottom

Current Size: 23.9M
Width: 30 cm
Height: 20 cm

[OK]
[Cancel]

New Size: 23.9M
Width: 30 cm ▲▼
Height: 20 cm ▲▼
☐ Relative

Anchor:

1/ 'Flood' is the result of first imagination and second combining just the right number of techniques to keep things straightforward but effective.

2/ Using canvas size, type in the width and height you wish to add space around your image ready for further enhancements.

3/ You can reposition the original image within the new canvas by clicking on to the desired position in the dialog box.

enjoy

'Flood' has been so successful it has been used in a number of exhibitions, both public and online. As for prints, A3 images from an ink jet printer were made at 1350 dpi. Using pigment ink technology for its longevity, this was output on to a semi gloss finish from the printer manufacturer.

shoot

A 2 megapixel compact digital camera was used for this shot. What that may lack in pure resolution terms, the photographer, Hans Claesson, has made up for with technique and vision. He chose the location at a specific time of day, when there was a strong wind creating the waves needed to get a good effect on the water from a slow

creativity first

Successful digital photography does not mean losing the proven techniques used previously for film capture. Depicting movement through a long exposure is as effective as it has always been, particularly when digital manipulation adds to the result. But getting things right in camera from the start saves time.

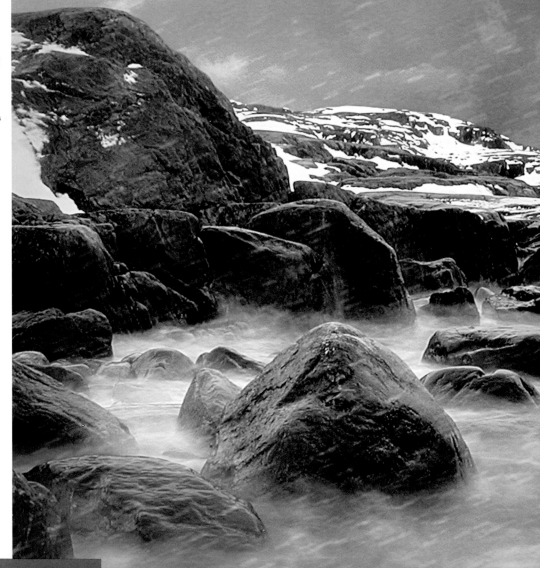

> digital capture

> filter

> photoshop

> layer

> **PSD** file

> ink jet print

> web

shutter speed. Having tried a few angles and some shots with different strengths of neutral density filter – <u>ND8, ND4 and an ND grad 0.7</u> – a reduction in the light reaching the camera's sensor and in turn, a suitable two second shutter speed at f/8 was obtained with the 100 ISO sensitivity set, was enough to blur the waves. A tripod and remote release are especially important when creating this kind of image, so too is getting down and close to the rocks. The results were pleasing, showing the Swedish West Coast as it can be; cold, hard, wet and unfriendly. But also beautiful and dramatic in its own way.

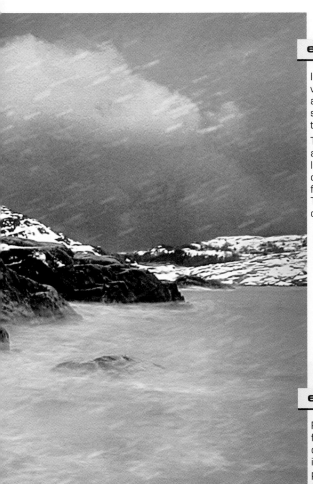

enhance

Images were reworked in a version of Photoshop. The snow and sky were modified using separate layers, always keeping the original files untouched.

The modified images were saved as <u>PSD files</u>, maintaining the layers and avoiding the degradation JPEGs can suffer from. The final image 'Essence Of The Season' was then ready for output.

enjoy

Prints are made first and foremost for the photographer's own pleasure. But they are shown in exhibitions and sold as framed prints. Hans also uses online selling and local stores to maximise his sales.

1/ In camera noise happens when pixels in a sensor generate a charge when they should not, resulting in coloured rather than black pixels. In camera noise reduction, a low ISO sensitivity, or if scanning film, a multi scan mode helps reduce it. Noise effect is not dissimilar to excessive grain in a film image.

2/ Adding noise through a software program can simulate this post-capture if desired. Noise filters are also used post-capture to help reduce such things as the effects of dust or scratches and are adjustable.

1 in camera noise

2 filter > noise

the human landscape

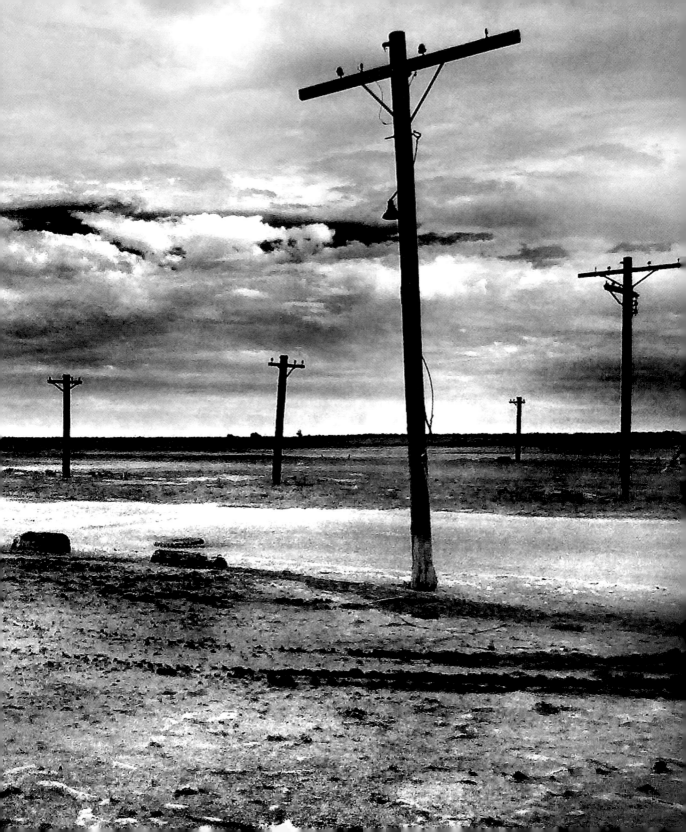

panoramic image

The land or cityscape lends itself to many picture shapes. Long 'panoramic' or similar often capture an expansive vista at its best. While there are cameras that can record this way, it is also possible to produce similar effects when combining images together. 'Manhattan Skyline' by Bob Reed is an excellent example.

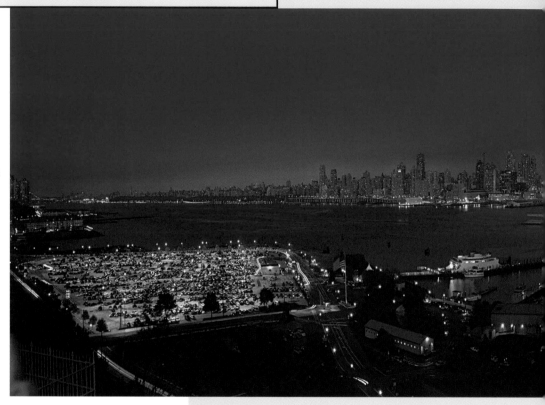

> 5x4inch film capture
> polacolor insight software
> new file
> cut/paste
> layers
> crop
> rotate
> skew
> eraser
> dodge/burn
> flatten layer
> clone tool
> gradient tool
> brightness/contrast
> hue/saturation
> curves
> gaussian blur
> cloning tool
> filter
> **USM**
> silver halide print
> ink jet print

shoot

Using a 'normal' coverage 150mm lens on his 5x4inch film camera, this image was created using three separate exposures. The aim was to cover the entire span of Manhattan from the Verrazano Narrows Bridge (far right), to the George Washington Bridge (far left). If the photographer's usual wide angle 47mm lens was used, it would also have covered the scene in single frame. But, light fall-off toward the edges would have been considerable, while the relative distance of the middle

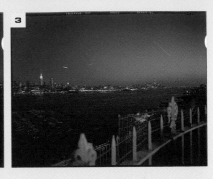

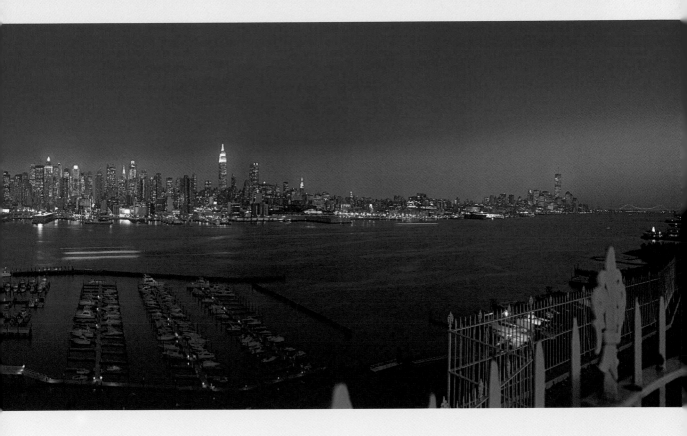

compared to each end several miles away, would have rendered the latter tiny and distorted. With a normal coverage lens, less exaggeration of scale was sought by overlapping frames. In turn a more pleasing perspective along the horizontal, much like the eyes take in while turning your head, was possible. Camera levelling, and marking of the three frame positions (on the tripod) were used so they <u>overlapped sufficiently</u> and roughly lined up.

! There are numerous 'stitching' programs available for compositing together images. Many are often included with compact digital cameras.

enhance

4/ Individual frames were copied and pasted on to the new background as an individual layer.

5/ The central shot was cropped slightly from each edge, so that the point of overlap between frames would be less distorted. The original central frame layer was replaced by the new middle frame.

6/ The baseline of the island was not a straight line, and the foreground was not linear where the frames overlapped. So further adjustments were needed.

7/ When all was aligned the background was fully cropped out.

All three frames were scanned using <u>Polacolor Insight</u> software with the same settings so that colour and density would approximately match (1/2/3). Each was made at <u>2000 dpi with 24-bit RGB colour</u>. The result was files ending up as several hundred Mb when the image was later worked on in Photoshop and layers. The three were then roughly composited by creating a new 16x6inch file with a white background. Then each frame was copied and pasted onto that background as an individual layer in Photoshop [4].

The centre image was cropped in slightly from each edge, so that the point of overlap between frames would be less distorted.

Then a new composite was created by deleting the layer containing the central frame, and re-pasting the cropped middle frame in its place. Layers were adjusted so that the <u>cropped frame was uppermost</u> [5].

As each layer can be moved separately, the left and right frames under the central one were adjusted until they approximately lined up. Then some of the white space in the background was cropped out. This resulted in a basic stitched together image. But because of the three different camera angles, lens illumination fall-off, plus elapsed time between exposures, the density and colour at each edge did not quite match,

and needed blending. Likewise the baseline of the island was not quite a straight line, and the foreground was not linear where the frames overlapped. There were also some moving boats and helicopters that appeared in more than one frame [6].

The left and right frames were repositioned until the perspective looked better [Layer > Transform > Rotate]. But while the buildings lined up, the boats and docks in the foreground did not. To correct the foreground perspective, the skew command was used [Layer > Transform > Skew], the left frame was stretched and squeezed into the right frame until the image looked better. Skew allows intentional non-linear distortion.

4

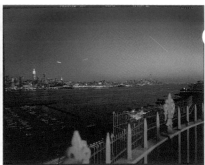

5

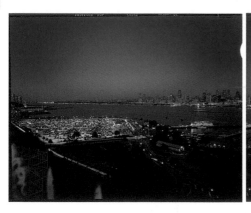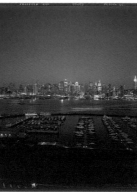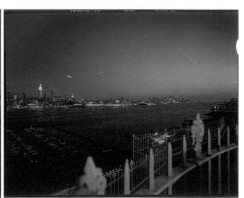

The background was also fully cropped out [7].

Several hours of subtle corrections came next. The sky areas were <u>blended</u>, first by gradual erasure of overlapping areas, followed by incremental <u>dodging and burning</u> at the edges, until the sky appeared uniform in tone. After flattening into one layer, the <u>cloning tool</u> was used to blend details in the mid and foreground areas. After selecting the sky area as a whole, grain was softened and dust removed. Several layers of <u>gradient colour</u> were also added to accentuate the dusk glow. The foreground area was then selectively lightened or darkened and blended until the lines of overlap

disappeared. Other touches were to straighten parts of the ferry boat on the left, while the docks were also lined up better.

Using <u>hue/saturation</u>, <u>curves</u>, and selective colour tools, the colour was adjusted, but some colour banding appeared as saturation was increased. This was removed with several and progressive applications of <u>gaussian blur</u> to the sky, with the skies selection contracted and feathered so that the building edges would not be affected. The cloning tool plus <u>dust and scratches filter</u> removed imperfections, with some selective <u>USM</u> carried out.

The image was cropped to <u>30x120</u>inch at 152.5 dpi (240Mb) for silver halide printing, but also 6x20 and 8x30inch <u>ink jet</u> prints were made along with a further 12x80 inch <u>silver halide</u> print.

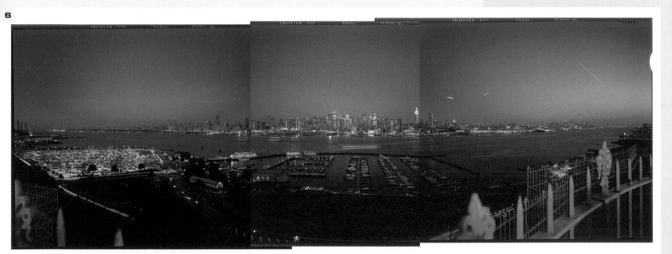

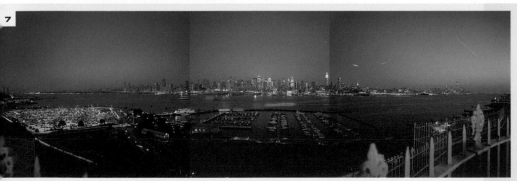

shoot

Taken on a compact digital camera during construction of the London Eye on the banks of the River Thames for the millennium celebrations, the weather was not great. The intention was to place this image on the photographer's website.

creating a sepia result

The photographic image exists mostly on paper. Throughout history numerous types have been used, many with a texture or visual appeal different to a common smooth surface, and some suit an image better than others. In this digital age it is as easy as ever to experiment using the ubiquitous ink jet printer, as 'The Eye' by James Burke shows.

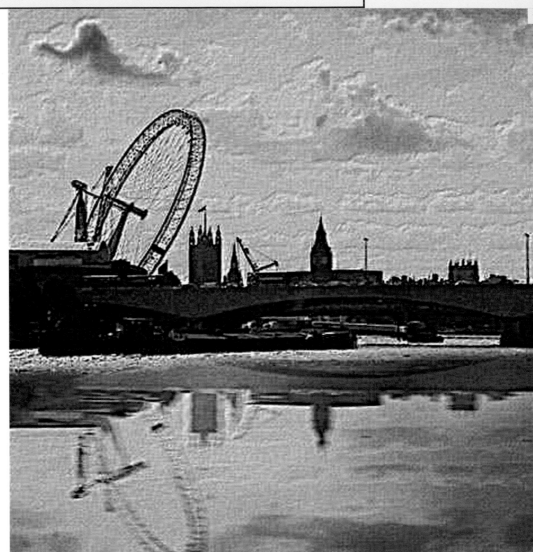

> digital capture

> crop

> clone

> duplicate layer

> flip canvas

> eraser

> hue/saturation

> colorize

> hue

> ink jet print

> web

enhance

It took around two hours to create in Photoshop. The image was cropped from its rectangular shape to a square shape removing distracting office buildings. The cloning tool removed flying birds which looked blurred. Next, the layer was duplicated [Layer > Duplicate Layer] and the copy flipped [Image > Rotate > Flip Canvas] to create a reflection. Then the parts which weren't over the water area were erased. The opacity of the copy was then reduced to allow some texture through.

Using hue/saturation [Image > Adjustments > Hue/Saturation] and selecting colorize [2], the hue was set to reproduce a sepia tone. Layers were flattened, (keeping a copy) with a texturiser applied, and a plug-in filter used to create a border which was distorted to fit the shape. Finally colour balance and saturation were adjusted.

enjoy

This image was output on to ink jet paper. James often resorts to using A3 cartridge paper from an artists' pad to add texture into the result, printing with the plain paper setting. While it uses more ink, better quality paper does not seem to 'bleed' too much as the ink dries fairly quickly.

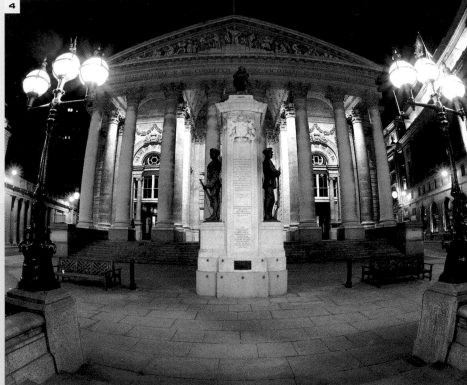

2 **hue/saturation**

Edit: Master

Hue: 72
Saturation: 25
Lightness: 0

OK
Cancel
Load...
Save...

☑ Colorize
☑ Preview

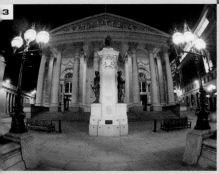

1/ Finished image.

2/ Hue/saturation filter.

3/ An image before it has been converted to sepia.

4/ Any image can be converted to a sepia result for an old world effect.

'Generally I want the image
to speak for itself.'

digital immediacy

One of the benefits of
digital capture is its
immediacy. The landscape
photographer rarely
needs to work at speed,
but there is another,
more subtle use of this
technology. It can make
our use of time far more
productive as 'New York'
by Steve Marley shows.

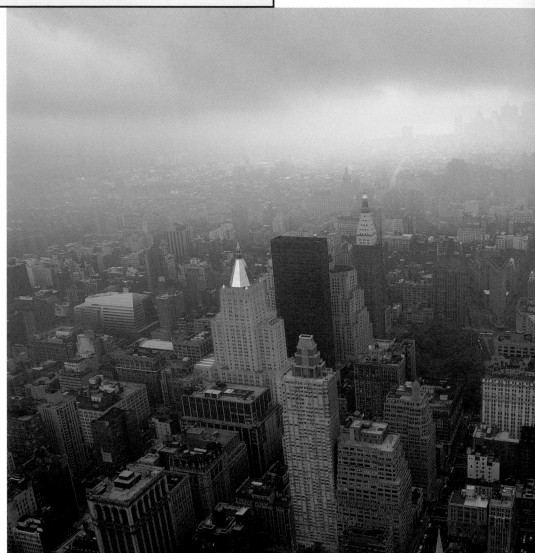

> digital capture
> RAW data file
> dedicated camera
 software
> TIFF file
> photoshop
> levels
> re-size
> A4 ink jet print

shoot

1/ A wide-angle zoom lens was used at its shortest focal length, to counteract a less than full-frame sensor in camera.

2/ EXIF data.

3/ Original image.

Shot from the top of the Empire State building, on the last morning of his trip from the UK, it was a miserable day, so much so that warnings at the bottom of the buildings said you could only see for two blocks. Steve hesitated to go up. The light was murky at the top but kept clearing slightly. After the effort, it would have been foolish not to shoot some images on his <u>pro level digital camera</u>. He used two lenses; a 14mm f/2.8 and a 17–35mm f/2.8 which on the camera's less than full-frame sensor, recorded a view equivalent to a 21mm and a 25.5–52.5mm zoom. The key was to make sure he had a good spread of exposures.

2 *These were the settings at the time this image was taken*

Sunday, August 12, 2001	Data Format : RAW (12-bit)	Lens : 17–35mm f/2.8-2.8	Metering Mode : Multi-Pattern	Exposure Difference : 0 EV	Sensitivity : ISO 125	Tone Compensation : Normal
7:59:13 pm	Compression : None	Focal Length : 17mm	1/90 sec-f/7.6	Hue Adjustment : 3	Color Mode : Adobe RGB	Sharpening : None
Color	Image Size : 3008 X 1960	Exposure Mode : Program*	Exposure Comp : 0 EV	SpeedLight Mode : None	White Balance : Auto	Model :Nikon D1X

3

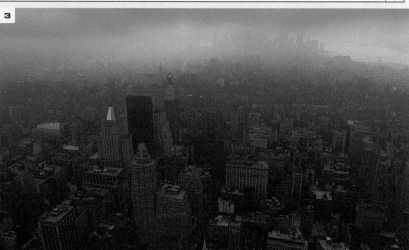

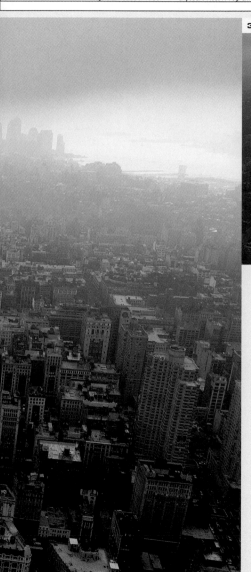

enhance

Steve knew he had a good shot amongst the series of images taken with varying exposures. He utilised digital technology further by processing the images on the plane on the way back across the Atlantic. As the image was captured using <u>RAW</u> data for maximum quality, it took a while using his dedicated software. Results were turned into TIFF files ending up as 30Mb. These were then opened in Photoshop with levels adjusted afterwards to cut through the cloud and bring out the detail in the image. Finally it was re-sized ready for printing.

enjoy

Premium glossy ink jet paper was the first output material used. But the potential was there to use something different so the shot was also printed on to watercolour paper and it looks good. In both instances A4 prints were made at <u>300 dpi</u>.

! RAW data can have its colour space adjusted when it is processed. Therefore different colour spaces can be used originating from the RAW unprocessed image.

ultimate colour

colour space

Most photographers prefer to work in colour. On a fundamental level 'colour harmony' is about matching pleasing colours together so they do not compete. But if they do, we get colour discord and the image will not look right. But how do you work best where colour is concerned? This is probably the biggest technical issue we face as photographers.

On the more advanced cameras, or within their dedicated software we can select the 'colour space' that an image is recorded within. A colour space is a range of hues and shades, plotted or mapped as a reference point on a colour model. In theory as an image is used, providing it is 'tagged' (colour space attached), any device using the same space will treat colours the same way. No device captures the scope we can visualise. There are two common colour spaces camera equipment is based around. Adobe 1998 RGB is offered with more advanced models, but sRGB is common to all. The first is a wider space, but the second closer to the colours that can be viewed on a monitor.

Depending on the output, one colour space is better than another. If your images are intended for the web then sRGB is all you really need. Monitors can not show other spaces in their entirety. sRGB also closely matches the gamut of silver halide prints, while many ink jet printers also convert to a near sRGB colour space before printing too. Capturing with sRGB allows a monitor to show similar colours and you can print similar colour with confidence in 'what you see is what you get'. But, an sRGB image cannot have that missing data reintroduced should you have a need to utilise it. Adobe 1998 RGB is a wider space. Its 'mapped' colours are proportionately reduced as they are 'shrunk' for output in the mentioned ways or viewed on screen. You capture more than with sRGB, but much of the subtle information cannot be displayed, although some can. This colour space is best when your images are used for a wider variety of reasons than those mentioned for sRGB, such as writing back on to film.

1/ RAW data is the most flexible when it comes to choosing what colour space your images use.

2/ Colour harmony; it may be subtle, often working on a subconscious level, but we have a lot of control over colour with digital imaging.

! Unlike a studio photographer who has control over consistency of lighting and can produce profiles for his or her entire workflow, a landscape worker can not as lighting changes throughout the day. But where it is physically practical, we can place a 'grey card' in a frame or at least the same light as a reference point. This can be beneficial in post-production for setting a mid-tone. It is also helpful for setting a manual white balance.

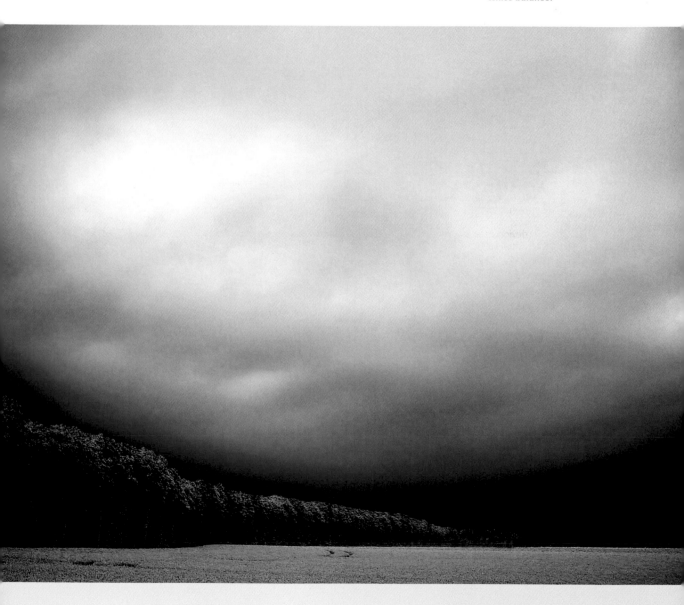

curves

Make curves your friend. For high quality reproduction, particularly for magazine and book work where colour is very important and must closely resemble reality, using curves [Image > Adjustments > Curves] can be crucial. This is particularly useful after selecting specific areas of the image and altering the colour balance within them. Being critical – even with high-end scanners – the colour balance across the highlights, mid-tones or shadows may not match the original image. When using curves it's important to use the info dialog box so you can see what's going on accurately, particularly if you are not using a colour-corrected monitor.

! Lab colour [Image > Mode > Lab Colour] is less prone to introducing a colour cast or cross curves than working in **RGB** or **CMYK**. It is a mode many photographers are still to discover for its benefits. It is the colour mode **Photoshop** and other programs use as an intermediate step when moving from **RGB** to **CMYK** or vice versa. It 'maps' colour coordinates from both more accurately than a direct conversion.

! A slightly flat or low contrast image on a monitor is not a bad image to send for publication or printing as these tend to increase contrast anyway.

1/ Curves is the best way using RGB and CMYK modes to counteract colour inaccuracy in differing parts of an image.

2/ Lab colour separates a lightness channel for colour. Changes to the brightness in an image will not introduce a colour cast as can happen when some effects are applied when not using lab colour.

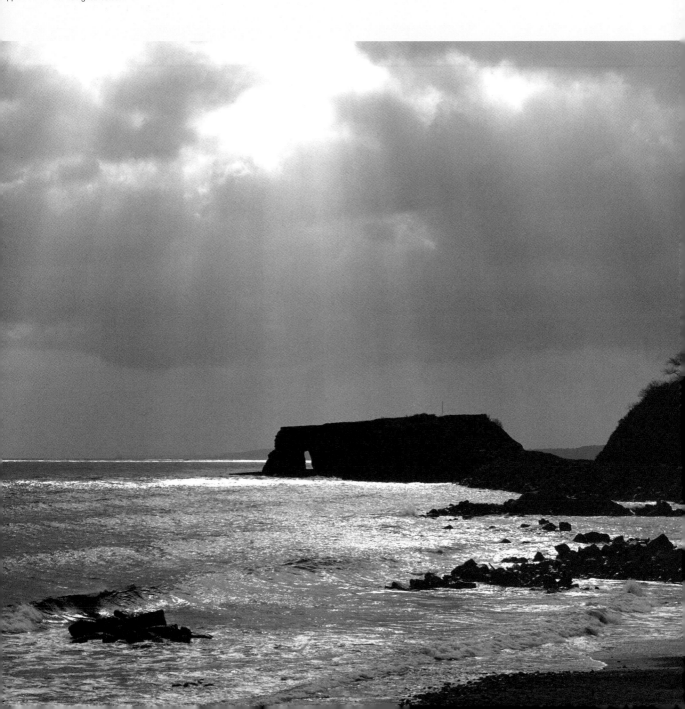

! It is best to archive images to **CD** as they are less prone to damage than a computer's hard drive.

! Some computer servers offer storage space and lots of it for your work.

! You can in some programs mark your files as copyrighted or for use in the public domain. It is best to do one or the other to avoid confusion and provide clarity.

storing and retrieving

store

In the digital age, there really is no excuse for being disorganised. Storage and retrieval has never been easier. Used properly, sales of your work can be increased.

Many cameras allow folders on a storage card to be named or at least given a numerical identification. If you are on a long shoot, maybe travelling away from base for some time, it is a good idea to put each subject as it is shot into numerous folders or one for each day, rather than use a single one. This will ease identification. While some use a laptop computer to download in the field, there are smaller pocket-sized storage devices with very large capacities, easing the need to carry lots of storage cards. These can be hooked up by USB or Firewire connection back at base. Make a back up as soon as you can.

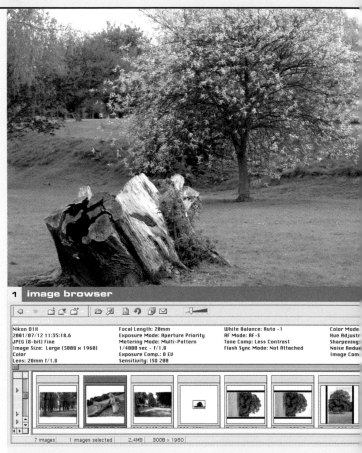

1 image browser

Nikon D1X
2001/07/12 11:35:18.6
JPEG (8-bit) Fine
Image Size: Large (3008 x 1960)
Color
Lens: 20mm f/1.8

Focal Length: 20mm
Exposure Mode: Aperture Priority
Metering Mode: Multi-Pattern
1/4000 sec - f/1.8
Exposure Comp.: 0 EV
Sensitivity: ISO 200

White Balance: Auto -1
AF Mode: AF-S
Tone Comp: Less Contrast
Flash Sync Mode: Not Attached

Color Mode
Hue Adjustm
Sharpening:
Noise Reduc
Image Com

7 images 1 images selected 2.4MB 3008 x 1960

> determine folder
> back up
> file browser
> correct
> copyright
> watermark
> share

browse

A file browser as the name suggests allows you to view thumbnails of an image or open at full size. Images can be sorted in a variety of ways; file size, date created, numerical order and others. While they allow simple adjustments, most file browsers allow you to open a more advanced software package from within the file browser.

! If embedding a watermark it is best to have an image with some change in colour or tone. It should be added as the last thing before compression.
A watermark's durability changes how easy it is to see. A stronger setting for instance is recommended for viewing ease with images placed on the web.

1/ The best file browsers display shooting data for the selected image to be viewed.

2/ You can often indicate apart from a © symbol, other data you may want to be used.

3/ A small portable hard drive is useful while out in the field. Download to your computer as soon as you can afterwards.

4/ Later versions of Photoshop incorporate its own browser [Window > File Browser]. Working on selected images is easy, just highlight those you want then open them.

5/ Copyright symbol in image title.

3

2 stored data

Caption
River bank flowers along the Chelmer.

Written by : John Clements
Headline :
Special Instructions :

Keywords
Water/flowers Add
Record Keywords: Delete

Locations
City:
State/Province:
Country:
Object Name:

Categories
3 letters short from :
Added Category: Add Delete

Urgency: Normal

Credit
By-line:
By-line title:
Credit: John Clements
Source:
Copy right: © John Clements

☑ **Date Created:**
26/ 4/2002
Original Transmission:

Simple... Save... Load... All Clear Cancel OK

4 selecting images

©JClements012_RT8.tif ©JClements013_RT8.tif ©JClements014_RT8.tif ©JClements015_RT8.tif

©JClements016_RT8.tif ©JClements017_RT8.tif ©JClements021_RT8.tif ©JClements022_RT8.tif

©JClements023_RT8.tif ©JClements024_RT8.tif ©JClements026_RT8.tif ©JClements027_RT8.tif

5 copyright symbol

© Water_flowers.jpg @ 25% (RGB)

enjoy

The most important thing when sharing your images is to make sure they are clearly copyright indicated. This can be done in many programs by attaching a © symbol to the title of the file. In Paint Shop Pro or similar [Menu > Image > Image Info], it will appear when a suitable file format is opened. But, this is not a guarantee it will always be seen, depending on the file format and program used. Embedding a watermark in an image is more permanent. But you will need to register your work to get a unique ID to use.

scenes within scenes

! If you want to combine images or try something different, layers in Photoshop [Layer > New] allows the original to remain unaffected. It is like placing a sheet of clear plastic over the original image and working on that. Further <u>layers</u> are added when needed, making it easy to retrace to a previous stage should you not like where you are at.

one image, many looks

shoot

Digital imaging opens up new creative possibilities even if the original image was captured many years before we had such capabilities at our finger tips. This is exactly what we have here.

Originally shot many years ago on transparency film, Leonard van Bruggen has since utilised digital manipulation to produce a variety of very different results from a single starting point. At the time it was created, difficult multiple exposures were used in camera.

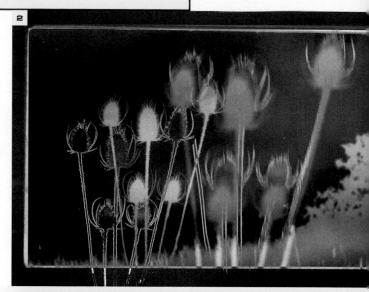

enhance

Making use of a flatbed scanner and optional film holder for up to 5x4inch film originals, this route provides a large file size to work from. Sometimes scanned positives and negatives are combined and layered in Photoshop to create surreal looking effects. <u>Layering techniques</u> are used in conjunction with various adjustments to brightness/contrast, hue/saturation or others like the invert command [Image > Adjustments > Invert]. This experimentation takes place relatively quickly.

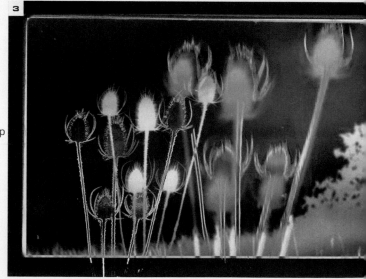

> **!** Merging layers also reduces the file size [Layer > Merge > Layers] but still enables work to be undertaken on uncompleted layers.

> **!** If you wish to save all layers this has to be done in the PSD format native to Photoshop. Otherwise, the image must be 'flattened' [Layer > Flatten Image]. This loses all of the invisible layers and keeps the file size down. It should be done on completion of the work when saving in a different format to **PSD**.

5 stylise > find edges

Artistic
Blur
Brush Strokes
Distort
Noise
Pixelate
Render
Sharpen
Sketch
Stylize ▸ Diffuse...
Texture Emboss...
Video Extrude...
Other **Find Edges**
Glowing Edges...
Digimarc Solarize
Tiles...
Trace Contour...
Wind...

4

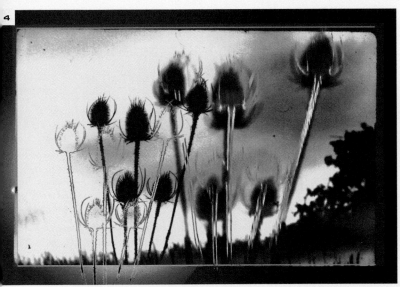

6 artistic > cut out

Cutout

OK
Cancel

50%

Options

No. of Levels 3

Edge Simplicity 4

Edge Fidelity 2

1/ Original image.

2/ Scanned in greyscale to create a monochrome version, duplicated as a background layer, then inverted with brightness/contrast, hue/saturation and opacity adjusted.

3/ Scanned in colour with various layers, adjusting brightness, colour, hue/saturation and opacity.

4/ Colour scan converted to greyscale, then to duotone [Image > Mode > Duotone] as a layer and adjusted. Converted back to RGB and flattened.

5/ There are many filters that can be used for effect when combining the same image on different layers. Here find edges [Filter > Stylise > Find Edges] has been used in Photoshop.

6/ Another combination that works with images like these is cut out [Filter > Artistic > Cut Out]. It produces results as if the image were made out of strips of coloured paper and is variable in effect.

7/ Combining the effects you want on different layers, with opacity of some adjusted to make them more or less prominent, can produce interesting results.

7 layers

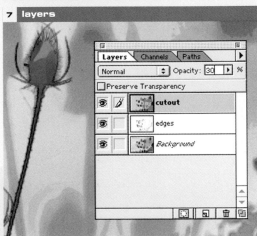

Layers Channels Paths
Normal Opacity: 30 %
Preserve Transparency
cutout
edges
Background

enjoy

Ink jet prints on glossy photo paper capture the most detail, or more artistic watercolour paper is used. Again, these add to the options and all are generated from one image.

! Move your subject to every corner of the viewfinder and then zoom up (or back up) and do it again.

! Keep all your in-focus pictures. I still go back and find ones that have something in them of 'value'. You can't work it if you don't have it.

an eye for detail

Small details often make for a good image within the landscape. The art is to let yourself take in your surroundings and the eyes adjust to the best possibilities. Sometimes you cannot see for looking, but as many photographers find, they settle into the rhythm of a landscape, and often that increases their perception.

2 intellihance pro

shoot

Captured with his digital camera, Mike McDonald had set a wide angle position on his zoom lens. A fast f/2.8 aperture was also used, slightly defocusing the background aiding the feel of isolation. This in turn enabled a 1/4000sec shutter speed under the lighting conditions at the set 100 ISO sensitivity. This dune shot was taken in Namibia, Africa, and was one of about 50 pictures taken around dusk. It was a small detail in an otherwise vast expanse, with no other obvious points of interest.

enhance

The image was worked on quickly with little change from the camera-captured file. In fact, using a plug-in for Photoshop from Extensis called Intellihance (quick enhance), was all it took to adjust the image. Interestingly, however, while the colours were saturated further, sharpening took place to a degree that it reintroduced the harder outline to the sand that the wide aperture sought to overcome at the onset. But the photographer ultimately decided this was the best version.

enjoy

Mike photographs for his own enjoyment but also to enter internet competitions and is often successful. A small fraction (less than 5%) are turned into prints and he utilises an A3 ink jet printer for this. However, most are now output via the internet on to photographic paper.

> digital capture
> photoshop
> plug-in
> extensis intellihance (quick enhance)
> web
> ink jet print
> silver halide print

3 **auto adjustment**

4 **sharpening**

1/ Original image.

2/ Screengrab of Extensis Intellihance Pro.

3/ Close-up of horizon without enhancement (sharpening).

4/ Horizon after sharpening is applied in auto adjustment.

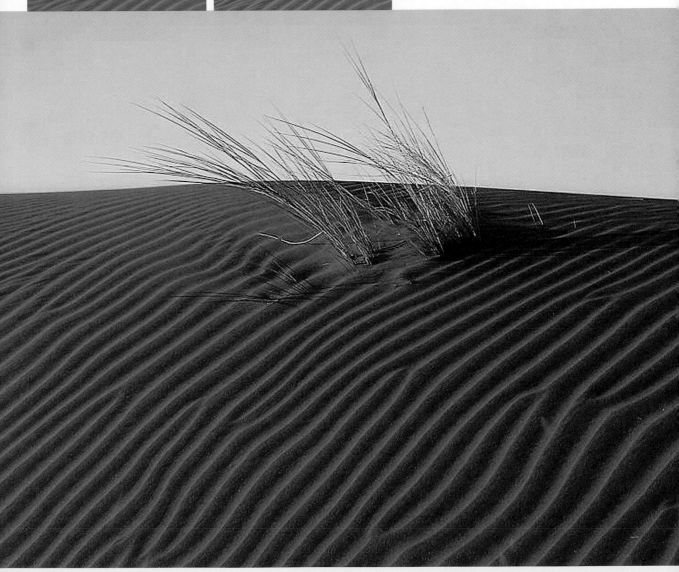

! Take advantage of the fact that each additional shot costs virtually nothing. Use different angles and settings.

small world, big possibilities

After the initial outlay, a digital camera is cheap to run and the best choice for carrying with you on the off chance of a picture.

shoot

While walking to his car to go shopping, Gary L Kratiewicz saw this leaf on his driveway after a rain shower. The way it looked against the wet pavement, particularly the water drops on the leaf which magnified its surface, convinced him he had to get the shot. Having a camera with him most times, his compact digital was set for 100 ISO sensitivity, giving a hand-held exposure of f/4 at 1/200sec.

enhance

The best result was obtained without any colour or levels adjustments, just a mild unsharp mask (USM). This is because his camera is set to soft sharpening and this counteracts the lack of bite. An aggressive crop showed off the details of the magnification caused by the water drops best.

enjoy

This shot won an online picture-of-the-day contest. Prints were made on to silver halide paper by an online producer, with the image set for 300 dpi. Prints were also shown at an exhibition in his church's art gallery which ran for several months.

> digital capture
> USM
> crop
> web
> silver halide print

'The "Ripple" images were taken with the idea of making a series of multilayered combinations, but I did not have a specific previsualisation in mind, just the concept that such combinations would probably work.'

solarise

Water is a remarkable subject, full of contradictions from the still and serene to the abstract. Freeze the motion and add some simple filtration for an interesting take as here with 'Ripple' by Ross Alford.

shoot

There were two images shot for 'Ripple' by Ross Alford. They were photographed with a compact digital camera at 1280X960 pixel resolution. They were then saved in RAW format and converted to TIFF files via the camera's TWAIN driver for Photoshop. Although he shoots film mostly he finds this low-res camera enables what he terms representational landscapes to be captured.

enhance

The first image, which we shall call Ripple 1, was created as a new layer. Then using the solarise filter [Filter > Stylise > Solarise] the image was inverted [Image > Adjustments > Invert] and auto levels adjusted [1]. The second image – Ripple 2 – was loaded and created as layer 2. This was modified by auto levels [Image > Adjustments > Auto Levels], solarised [Filter > Stylise > Solarise] and auto levelled again [2]. Then after selecting all of the layer 2 image, it was copied and pasted on to layer 1 image. The PSD was then flattened and finally the image size set.

> digital capture

> RAW data

> TIFF file

> photoshop

> layer

> PSD file

> solarise

> invert

> auto levels

> ! Depending on the software program, it may not be possible in all colour modes to use the solarise or similar filters.

enjoy

This image has been uploaded to the photographer's website. In addition he makes small ink jet prints for his own enjoyment.

1/ The first image was created with the solarise filter.

2/ The second image was modified and pasted on to the first image as a new layer.

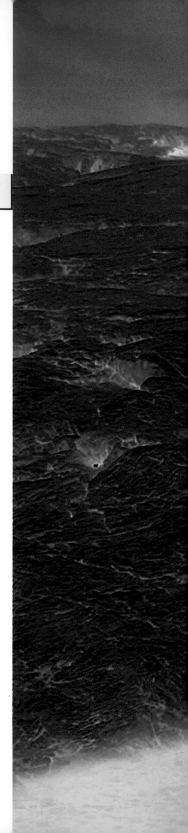

a harsh and angry world

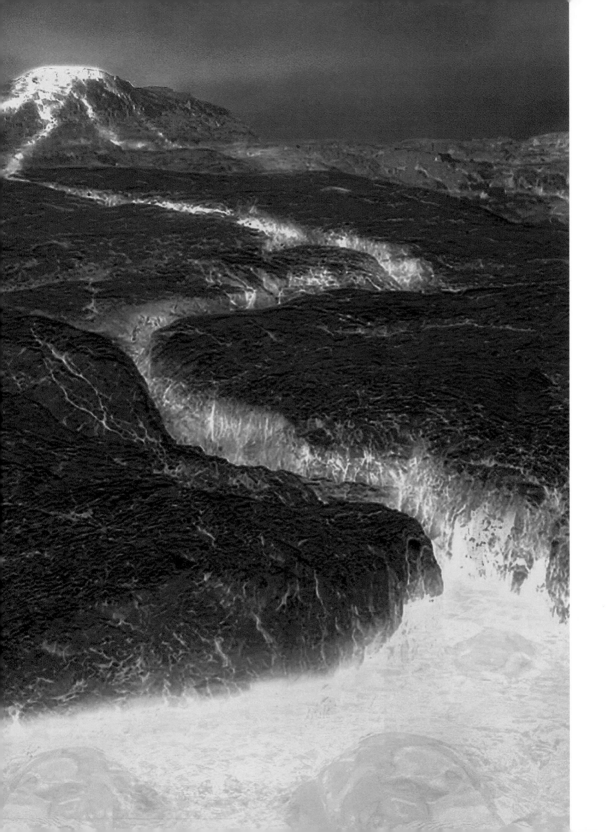

'I ask myself: What would I not expect in this scenario? For me it is the best way of making interesting pictures.'

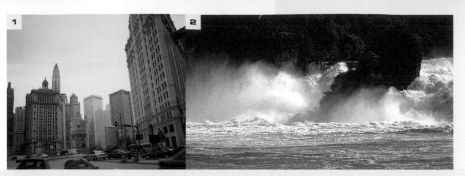

creating drama

Thomas Herbrich shoots high quality film originals. But it is digital imaging that allows him to create what is in his mind's eye.

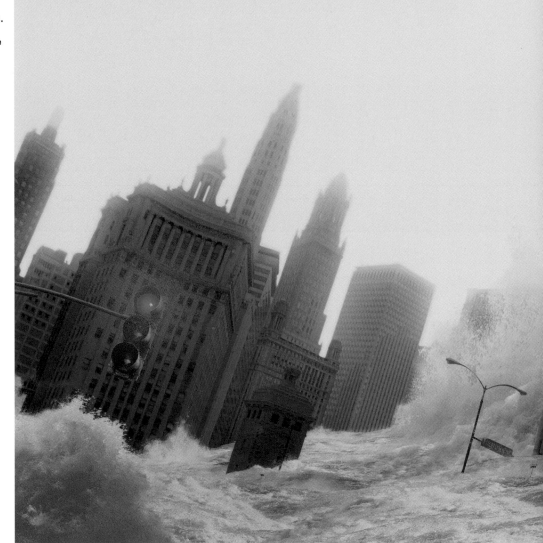

> medium format film capture

> 35mm film capture

> scan

> eclipse software

> colour sky

> slope building tops

> colour building tops

> radial vignette

> noise filter

> film

> magazine repro

> calendar

> web

Although expensive, outputting images back out on to film is a good storage method, as silver halide materials hold lots of data securely over time when stored properly.

shoot

Both the city scene [1] and the traffic lights were shot in Chicago. The water came from images taken at Schaffhausen in Switzerland [2], Europe's biggest waterfall. Through exposure a dark background was deliberately sought – even though it was a sunny day – as this made the water easy to select and work on.

enhance

Only one software program, Eclipse is used (http://www.formvision.de). Made for big files, an attraction is the auto mask function that separates objects from a background [3], by picking a colour – in this case light blue over the water – and defining it as a mask. Other tools added further refining options, including a little softness for this image. Around 16 water images were combined for effect. The skyline was retouched for a slightly foggy, 'rainy day' mood, by adding a touch of light blue to the sky and a low density white over the building tops. These were also 'sloped'. The traffic light was enhanced by adding a ball of colour called a 'radial vignette' [4], using a low density to make the red light more 'active'. The high resolution and grain-free look of the image was not completely what was wanted, so a noise filter was used, giving a closer feel to a 35mm news photograph. The final image was an 80Mb file (scanned at 1000 dpi and interpolated). It was output back to film as an 8x10inch transparency.

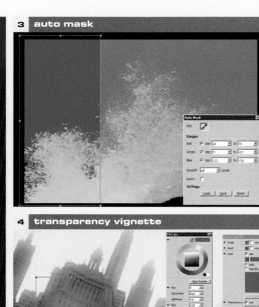

3 auto mask

4 transparency vignette

1/ Original Chicago image.

2/ Original waterfall image. One of 16 waterfall images that were combined for effect.

3/ Selecting the water ready for adding to the image within Eclipse software as an auto mask.

4/ A radial vignette enhanced the traffic light for impact.

enjoy

This image was part of the photographer's calendar and made for his own training. It has featured as a double-page spread in ARCHIVE magazine, an advertising publication, and as part of his lecture show.

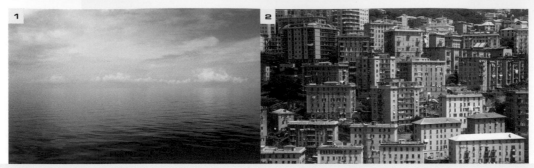

distortion for impact

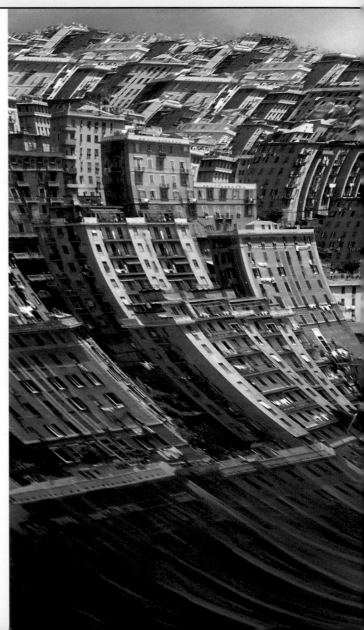

shoot

You can shoot numerous images and spend many hours in thought before an idea comes to mind. Then it's a small matter of the technicalities to bring it to fruition. That is how Paul Williams created 'Tide Of Progress'. It creates thoughts about rising sea levels due to environmental changes.

As a ship's photographer Paul Williams served on the SS Canberra when the component parts of this image were taken. Using an SLR loaded with 100 ISO film and fitted with a 28–70mm wide-angle zoom lens, there are two main pictures. The first was a shot of the ocean – something not surprisingly Paul did often – and the second, a cityscape of Genoa.

> 35mm film capture

> scan

> photoshop

> rotate

> shear tool

> layer

> shear tool

> layer

> gradient mask

> ink jet print

> web

'Making this image
involved a steep learning
curve for me as I was
using techniques which I
had not attempted
before.'

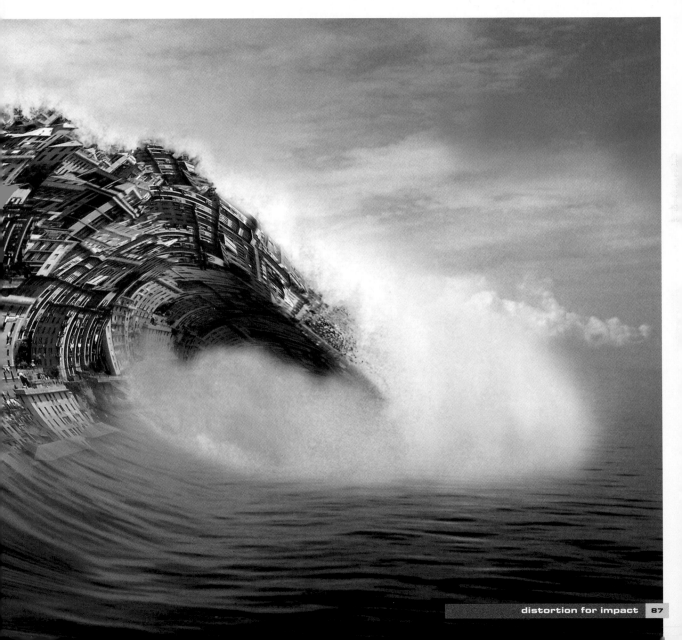

It took a long time for the combined images to take shape. The base image was the seascape which was altered using the shear tool to bend the image and form the base of the wave. As the tool only works vertically, a section was selected, rotated through 90°, altered, then rotated back again and positioned on the image [4/5]. This was done repeatedly to successive layers of the image until the desired effect was achieved.

The next stage was to create the top section of the wave using again the shear command repeatedly on the image altering the settings to achieve the correct curve. As the curve alters along the length of the wave it

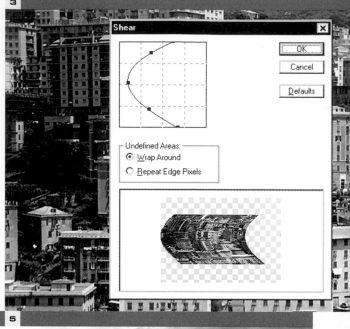

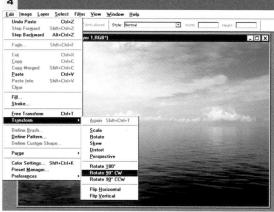

was possible to use a portion of the sheared cityscape each time [3/7/8/9]. This was done by selecting the area to use and dragging it into the main image, using layers to build the wave. To create the funnel effect on the end of the wave, a gradient mask was used to darken the area to give it a 3D effect [10].

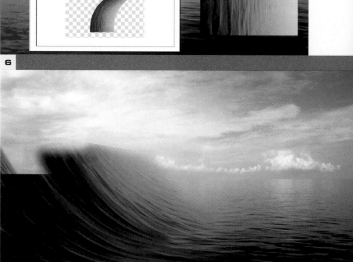

3/ The shear tool was used to bend the wave.

4/ The selected section was rotated 90 degrees; shear applied, then rotated back again.

5/ Applying the shear tool at different settings ensured the correct curve.

6/ The final curve effect.

7/8/9/ The sheared cityscape was added a bit at a time to match the wave position using layers.

10/ To help with the 'funnel' effect, a gradient mask was used to darken the tip of the buildings.

11/ The final effect was enhanced with the tip of the citysacpe being surrounded in water spray.

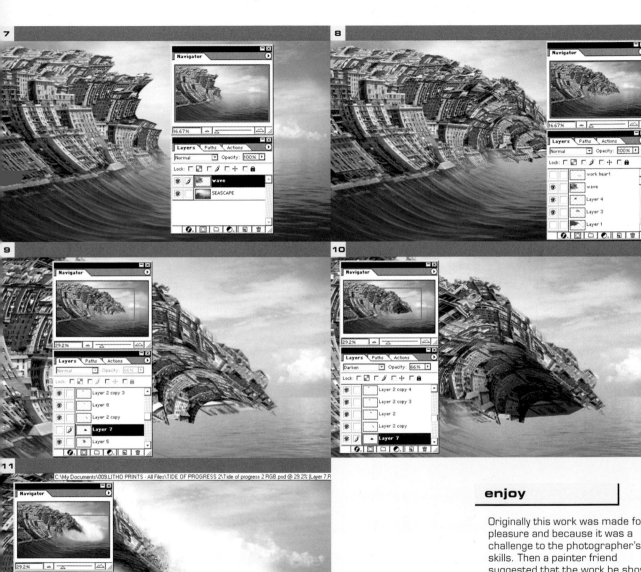

enjoy

Originally this work was made for pleasure and because it was a challenge to the photographer's skills. Then a painter friend suggested that the work be shown in a local gallery. Now Paul sells prints like this to the public in limited editions. Ink jet prints are made to A3 size using an archival matte paper. The image is also on his website.

'I wanted to capture the sea in a state of motion by using an infrared filter which let me use a very slow shutter speed to blur the water. This filter also brings out the plant life on the rocks and the flowers in the foreground. I included these and the curvatures along the coast to give a sense of depth. The lighthouse in the background complimented the shifting sea and shoreline.'

shoot

Using a compact digital camera, Stephan Donnelly created this striking image. This shot utilised a Hoya R72 infrared filter. The tripod-mounted camera was exposed at a shutter speed of 2.5secs with an f/8 aperture at ISO 50 sensitivity. A near 50mm equivalent focal length in 35mm film terms, gave a conventional view point. Finally the white balance was set to match the 'cloudy' conditions.

1

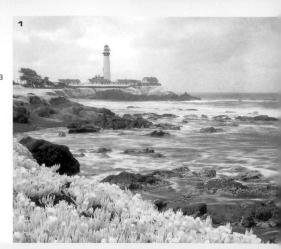

correcting a slanting horizon

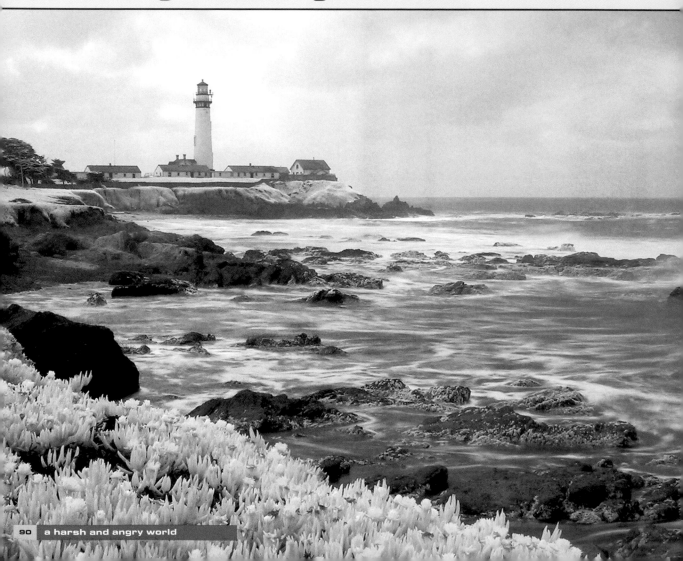

'Being unable to wait for the weather to change, I used what I had available to make the best of the situation.'

enhance

The image was duplicated keeping the original intact and converted to <u>lab colour</u>. Using the channels palette in Photoshop, and choosing the lightness channel, the image was taken to <u>greyscale</u>, discarding the other channel options. A background layer was duplicated, with a <u>levels</u> adjustment layer to bring out the best tonal range. As the horizon was slightly off, Stephan chose the <u>measure tool</u> to trace the horizon which told him this was exactly by .3 degrees [2/3]. The canvas was then rotated using the <u>arbitrary</u> setting [Image > Rotate Canvas > Arbitrary], with

.3 in the dialog box set to counteract [4]. By extending the canvas area to see the edge of the image, the extra white area around the edges was cropped.

To sharpen the image, an '<u>action</u>' that converts the image back to <u>lab colour</u>, (selecting the 'a' and 'b' channels separately), and applies a slight <u>gaussian blur</u> to get rid of excess noise was carried out. Finally it selects the 'lightness' channel and applies an <u>unsharp mask</u> to this with settings of; 85 for amount, 1 for radius and a threshold of 4. Final conversion is back to greyscale.

2 | measure tool

3 | measure tool info panel

| X: 3.12 | Y: 1.61 | W: 2.42 | H: 0.02 | A: -0.3° | D1: 2.42 | D2: | Clear |

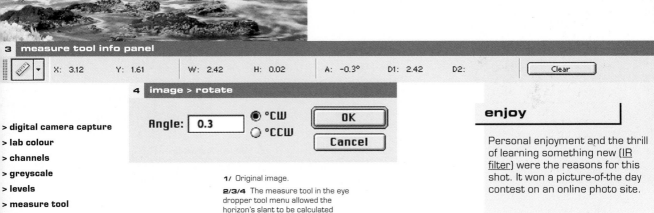

4 | image > rotate

Angle: 0.3 ● °CW ○ °CCW OK Cancel

> digital camera capture
> lab colour
> channels
> greyscale
> levels
> measure tool
> canvas
> crop
> lab colour
> sharpen
> gaussian blur
> sharpen
> USM
> greyscale
> web

1/ Original image.

2/3/4 The measure tool in the eye dropper tool menu allowed the horizon's slant to be calculated then corrected using the 'arbitrary' command. The measure tool's info panel shows a variety of data.

enjoy

Personal enjoyment and the thrill of learning something new (<u>IR filter</u>) were the reasons for this shot. It won a picture-of-the day contest on an online photo site.

black and white never fades

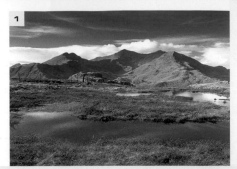

monochrome reworked

! As with colour work, experiment with the white balance options to achieve different results in camera.

There are numerous ways to create a monochrome image. Depending on your needs and working style, some will be better than others. Here we outline some key issues for achieving black and white delight.

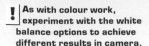

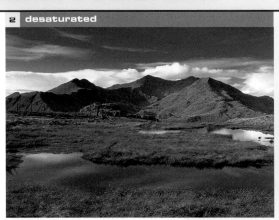

2 desaturated

3 hue/saturation

shoot

Digital capture in all but a few cameras allows greyscale images to be created. Although the same sensor is used as for colour image creation, not having all of that data as it is stripped out, in turn means smaller file sizes compared to the same shot in colour. If you do want to capture in colour, then this can be removed afterwards.

enhance

To remove colour and create a greyscale image is straightforward and there are numerous ways to do it using most software packages. Desaturate [Image > Adjustments > Desaturate] in Photoshop is one way [2]. It strips out the colour in one easy step, equally from the RGB file. Alternatively, the hue/saturation [Image > Adjustments > Hue/Saturation] control can be used with the saturation positioned at -100 [3/4].

Another, and probably underutilised option is the channel mixer [Image > Adjustments > Channel Mixer]. While this is used also for colour

images, with the monochrome box checked, any image is converted to greyscale. It is still technically an RGB image, but that offers some advantages. By adjusting the separate RGB channels of the image, a result a little like filtering on camera for tonal range and contrast control can be achieved. The brightness can also be adjusted via the 'constant' control [5/6]. If the monochrome box is unchecked afterwards, you can adjust the colour sliders to introduce some interesting split-tone effects. But most people opt for taking the image to greyscale via the greyscale setting [Image > Mode > Greyscale] [7].

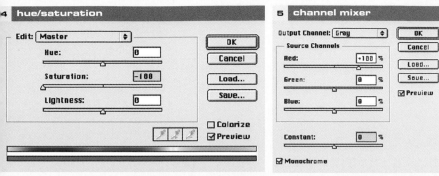

4 hue/saturation

Edit: Master

Hue: 0

Saturation: -100

Lightness: 0

OK
Cancel
Load...
Save...

☐ Colorize
☑ Preview

5 channel mixer

Output Channel: Gray

Source Channels

Red: +100 %

Green: 0 %

Blue: 0 %

Constant: 0 %

☑ Monochrome

OK
Cancel
Load...
Save...

☑ Preview

1/ Original colour image with manual levels correction.

2/ The desaturate command removes the colour from the colour mode you are working in.

3/4 The hue/saturation command can be used to remove colour by setting saturation levels to zero.

5/6 The channel mixer is underutilised for both colour and monochrome work with RGB and CMYK colour modes.

7/ The greyscale mode uses 256 shades between white and black, and is considered a high quality option.

8/ Adding colour back to monochrome adds to the flexibility of the landscape worker.

6 channel mixer

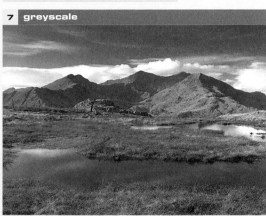

7 greyscale

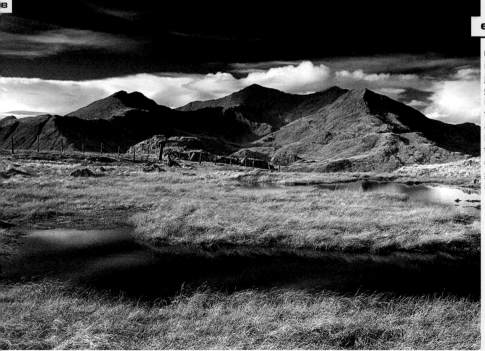

enjoy

Getting the best monochrome image when outputting on to ink jet paper is best done with <u>small gamut</u> inks. These replace colour inks and provide potentially near a full tonal range. You can print with a printer loaded with colour and black ink, but this will limit the tonal range, and makes a colour cast more likely. Output on to <u>silver halide</u> paper has the usual advantages.

1

selective contrast control

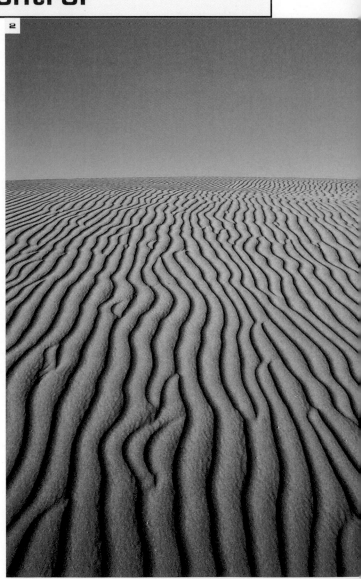

2

shoot

Many photographers continue to find their calling creating black-and-white imagery. Jeff Alu is one of these. A 3D artist/animator he has been shooting black-and-white photography in an attempt to get back to the basics of light and shadow. All of the work shown here was created with the same basic techniques and shows the magic that is mono. Particularly important as it was for traditional darkroom work is the use of <u>digital</u> dodge and burn techniques.

A compact digital camera was used for these images by Jeff Alu. It appealed for its simplicity as the preferred shooting technique is for the most part point and click. These are therefore hand-held. Due to the main subject matter, the photographer often finds himself three hours from home in the middle of nowhere. Pictures are captured in colour, with a polarising filter attached. The act of photography has come out of a love for hiking through the deserts on very hot days. Not waiting in one spot for very long, many shots are captured while on the move, with his interest mostly in finding new areas to photograph. The images tend to be graphic in nature, with strong leading lines.

> digital capture

> channel mixer

> greyscale

> dodge and burn

> sharpening

> contrast adjustment

> web

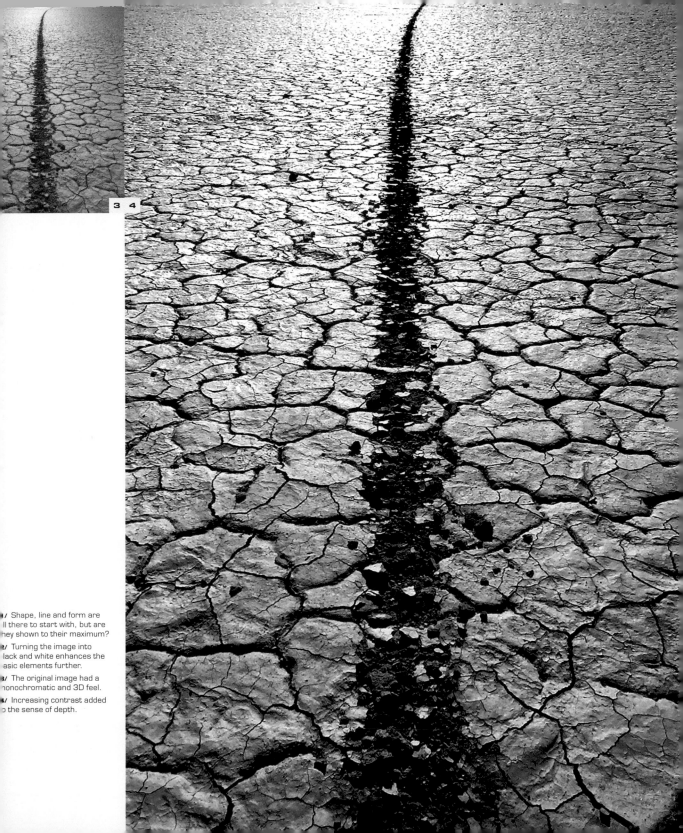

3 4

1/ Shape, line and form are
all there to start with, but are
they shown to their maximum?

2/ Turning the image into
black and white enhances the
basic elements further.

3/ The original image had a
monochromatic and 3D feel.

4/ Increasing contrast added
to the sense of depth.

'I've found this to be such a great technique for isolating subjects or bringing out emotions. I didn't dodge and burn at first, but now I do it on every image.'

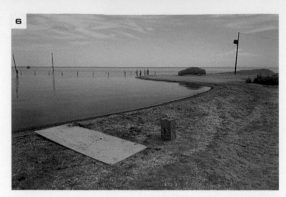

6

7

enhance

5/ Traditional darkroom shows its influence with the popular dodge and burn tools. These selectively lighten or hold back parts of an image (dodge), or darken (burn) depending on which tool is chosen. There is plenty of control to exert through brush size, exposure and the ability to work on highlights, mid-tones or shadows separately.

6/ In colour the image was no more than a snap.

7/ In monochrome it becomes an image of slight mystery.

Once in computer the image is converted to black and white using the channel mixer with the monochrome setting checked. This allows for subtle variations in the overall look and helps to cut down on the graininess of the sky. An interesting aside is that the photographer tones down the red channel because his compact digital shows some noise and this counteracts it. Next comes dodging and burning in with the dodge and burn brush – something he feels to be by far the most important part of the process. It also was a skill initially learned in an old fashioned darkroom environment. Then there is some unsharp masking [Filter > Sharpen > Unsharp Mask], usually in two stages. First a high radius is chosen – maybe around 50 and a low 'amount' say 29 – this makes larger details stand out a little better. The second is a low 'radius' – .8 and a high 'amount' maybe up to 70 –

and this does the actual sharpening, but the values vary depending on the picture.

Finally a little contrast enhancement may be added. In this – a selective contrast control – the dodge and burn brush is used again. This allows easy brightening of the highlights and a darkening of the shadows by painting on the image. You can control what you want to work on: highlights, mid-tones, or shadows. For instance, with a sky and bright clouds and a darker 'blue' area for example, the brush can be used to burn the darker areas and paint on the image. These then become totally black, while the bright clouds are not affected. It's a great way to achieve selective contrast enhancement, and of course you can also control the strength of the brush. Sometimes you may see the brush strokes, so using a softer brush can help.

enjoy

These images have been placed on the photographer's website.

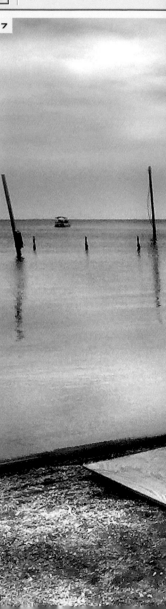

'Many of my clients demand high-impact, colourful graphics, which have their place to be sure. But, it can often become overwhelming, and the act of doing black-and-white photography clears my mind a little.'

File Browser | Brushes

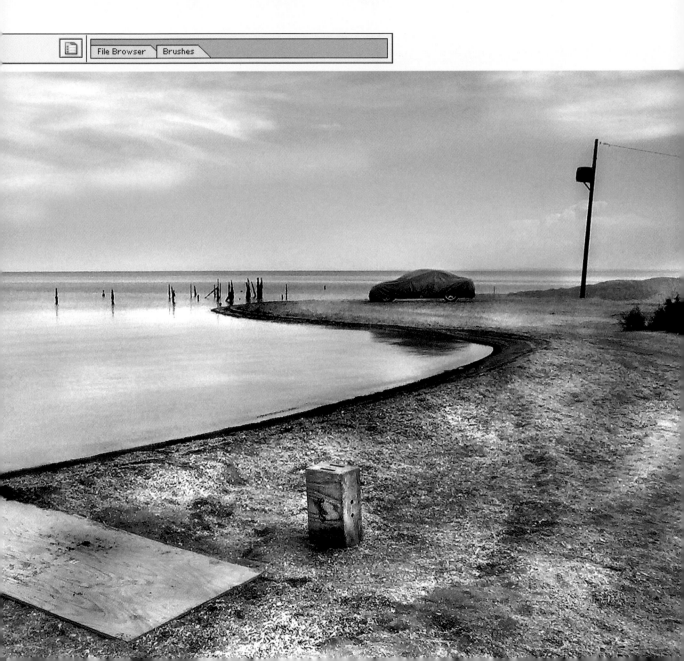

> '**Infrared gives the ability to literally view the landscape in a different *other worldly light*.'**

1/ Original exposure; equivalent 38mm focal length, 80 ISO, 1/48sec at f/2.6.

2/3/ Adjustment was made to increase contrast using levels.

eye-catching monochrome

shoot

Infrared imaging is a good choice for the landscape photographer as the technique benefits from foliage in a scene giving a high key effect as with this shot. But other components, like the iron fence, maintain a closer resemblance to reality. The two act as a visual double take. First you see the familiar, then look again at the unfamiliar as it grabs your attention.

Even though a bright sunny day the strength of lighting was reduced by having a suitable filter attached. As with 'April Fog' (see overleaf), the camera was set to record in black-and-white mode, and both were captured hand-held – although normally a tripod is used to allow for a slow shutter speed – often needed to counteract the light absorption of a filter. Without SLR viewing, the camera's LCD was used to compose the shot.

'Taken on a bright summer day at the Cornell Plantations, I liked the contrast of the bright foliage and clouds with dark sky and black iron fence.'

enhance

Apart from some minor levels adjustment to set the desired brightness and contrast [Image > Adjustments > Levels] [3], that was it as far as image enhancement was concerned. For printing, the image was first converted back from greyscale to RGB mode, and a special adjustment curve applied to provide the monochrome tones sought in the print, with the specific paper and inks chosen. A neutral image was sought.

! This and other adjustment curves were downloaded from:

www.inksupply.com/index.cfm? source=html/workflow_roark

Those who specialise or manufacture sometimes allow people to download and use the results of their labours via the internet, so we can get the best out of materials. Adjustments such as this are for specific paper and ink combinations.

> digital capture
> manipulation software
> image
> adjustments
> levels
> applied printing curve
> ink jet print

2 levels original

Channel: Gray
Input Levels: 0 1.00 255
Output Levels: 0 255

OK
Cancel
Load...
Save...
Auto
Options...
☑ Preview

3 levels corrected

Channel: Gray
Input Levels: 0 1.00 255
Output Levels: 0 255

OK
Cancel
Load...
Save...
Auto
Options...
☑ Preview

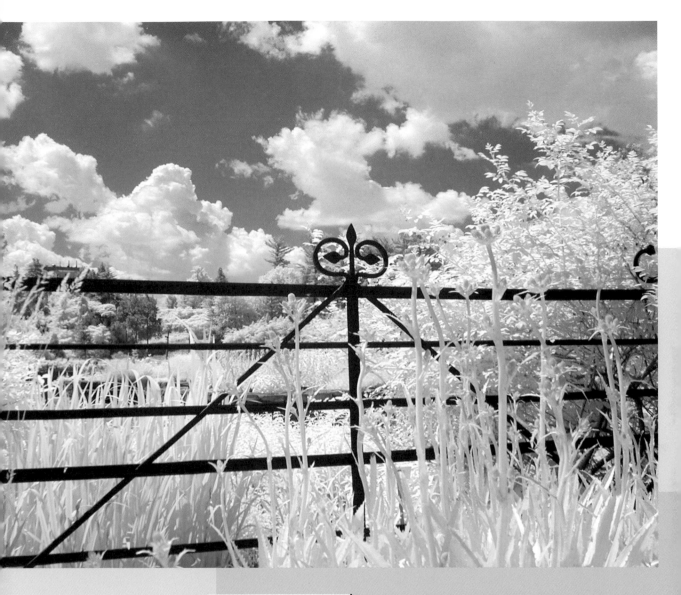

enjoy

Carl Schofield has output this image using an ink jet printer. <u>Archival matte</u> paper from his printer manufacturer as well as third party paper alternatives give him what he is after. Pigment inks for longevity are used. His A3 printer is set to <u>240 ppi</u> and the image sized for whatever the desired print dimensions are such as 7x5 or 8x10inch. His favourite finish would be to use this image in a black aluminium frame with a white mat.

1

2 ☐ crop tool

digital infrared photography

shoot

Carl Schofield has not shot a film image for many years, stating that he obtains better quality images and prints with his high-end digital SLR, than with silver halide materials. He has a real taste for capturing digital infrared images. 'April Fog' was taken with a compact type digital camera, and shows the importance of the creative process being as much, if not more than the equipment.

The key to creating this image from a technical viewpoint is the use of a suitable infrared transmitting filter. The exposure was 1/8sec at f/2.6, outlining the need for a tripod or other support for much infrared photography as suitable filters reduce light transmission noticeably. The focal length was the camera's widest marked as 7mm. Based on an angle of view taken from the camera's 1/2 inch CCD, this equated to a 38mm lens on a 35mm film camera.

While most of his photography is preconceived and planned, this shot was taken while Carl was on an early morning stroll at the edge of Cayuga Lake. He spotted this man dressed in cowboy clothing sitting on the swing, who stayed there just long enough for the photographer to take this shot. Its success in part was down to early spring green foliage and grass which adds a high key effect when recorded in infrared. The image was saved as a 'fine' low compression JPEG file.

> digital capture **JPEG**

> crop

> dodge

> clone tool

> levels

> re-size

> manipulation software

> ink jet print

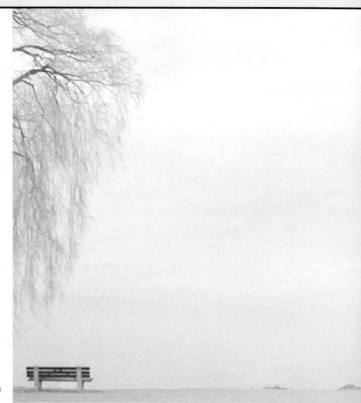

'**Most of my infrared work was preconceived and planned, but "April Fog" was primarily a matter of being in the right place at the right time.**'

❗ Shoot, shoot and shoot some more. Storage cards are relatively cheap and one should not feel inhibited to experiment with different compositions and techniques when shooting digital.

enhance

The basic image file [1] was cropped quite severely to enhance the feeling of isolation and the balance of the composition [2]. It was then dodged to let the foreground grass area have the impact the photographer desired by using the <u>dodge brush</u> in Photoshop. The effect was set to approximately 20% and for mid-tones only [3]. Retouched to remove the other unwanted

3 dodge tool

Opacity: 20 %

OK

Cancel

Mode: Normal

☑ Preview

elements from the scene with the clone tool, final enhancements were to adjust the levels and then re-size. <u>Levels</u> were set manually by moving the gamma slider to increase the overall brightness. In all, this was about an hour's work.

There are many filters from specialist photographic retail outlets suitable for near or purely infrared photography. Typically we need a filter with a transmission range above <u>800nm (nanometres)</u>, to block other parts of the spectrum from reaching the camera's sensor and destroying the effect. The visible spectrum in comparison covers from around 400nm to 700nm. In the course of this book they have been mentioned by numerous photographers.

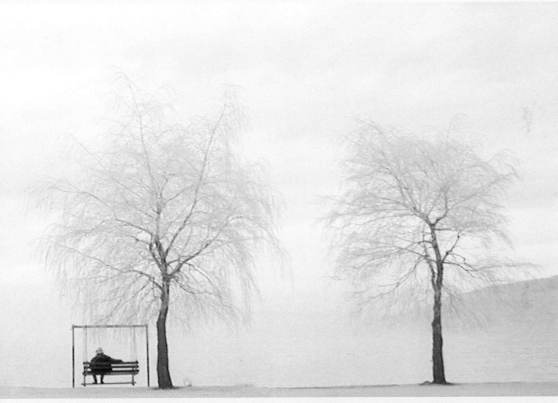

1/ Original exposure; equivalent 38mm focal length, 80 ISO, 1/18sec at f/2.6.

2/ The rectangular marquee tool was used to crop the original image.

3/ Next the dodge tool was selected and the opacity was set to 20%.

enjoy

This image is selling through a local gallery and has been a success in photographic competitions. Prints are made on an ink jet printer capable of

<u>A3 size output</u>. The printer manufacturer's own <u>archival matte</u> paper or third party papers are used by the photographer, with archival carbon pigment inks

being loaded for longevity. The image is placed in a Neilsen white aluminium frame on a white window mat, to accentuate the high key nature of the print.

landscape art

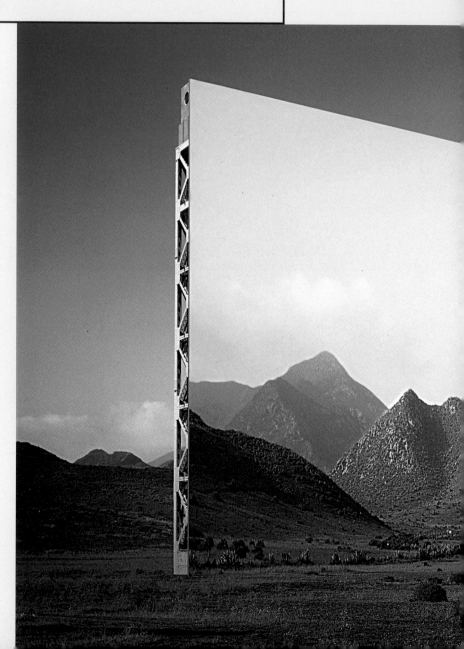

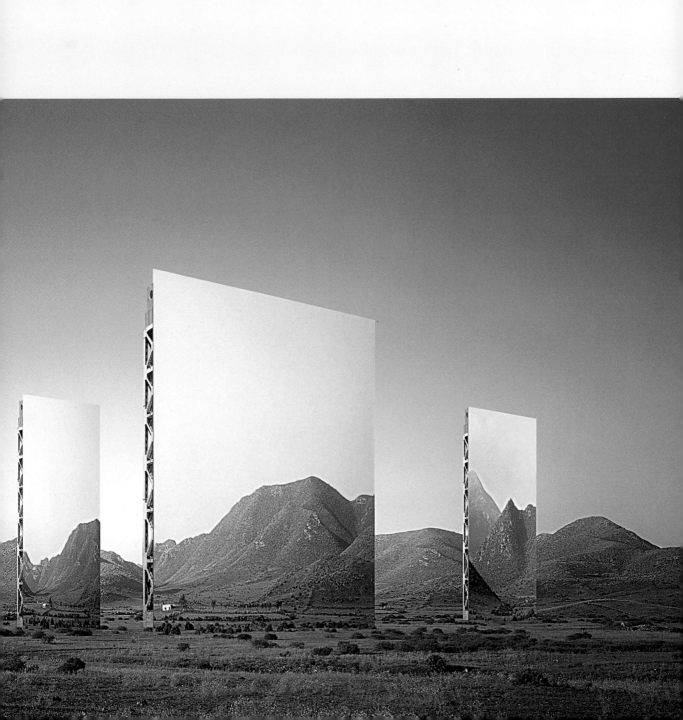

'I believe the end result is always much more important than the idea itself, something modern art seems to disagree with.'

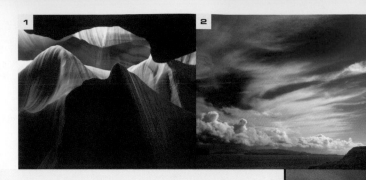

montage for impact

shoot

For some photographers being tied to a traditional and natural looking image, stifles creativity. With the help of various techniques, Tony Howell has created something slightly surreal.

This image is composed out of four original transparencies, taken with a 6x6cm medium format camera with an 80mm or 50mm lens. The photographer works by preconceiving an idea, then shooting various images if not already on file to achieve the result. In the case of 'Canyon Sky Montage' he wanted to show a deciduous tree without leaves in a desert situation, something that is not a common sight.

! I like to work with small file sizes (less than 100Kb) when I alter images. This is useful if your computer is slow (like mine) as you can see changes instantly. Then if I like the results, I will recreate them using file sizes around 20Mb.

! I really like the invert command in Photoshop, which turns your picture into a negative. I find it works best on very simple images. The colours that can be achieved are really beautiful, with at least 50% of my best work involving at least part of the image being inverted.

enhance

In total, up to a day and a half of work time has been spent on this image. First the shot of Antelope Canyon taken in Arizona which was rotated 90°. The lasso tool was used to select around the rocks before cutting and pasting on to the image of the sky which was shot in Scotland. Next the tree image, selected by using the colour range option [Select > Colour Range] was pasted on to

the image and positioned with the help of the move tool. Levels were then adjusted to make it more green, before free transform [Edit > Free Transform] changed the shape to suit the image better before pasting on to the desert image. The eraser, blur and burn tools were then used to blend the rest of the image before the whole thing was flattened.

> 6x6cm film camera
> scanner
> photoshop
> lasso tool
> colour range
> move tool
> levels
> free transform
> eraser
> blur
> burn
> ink jet print
> web

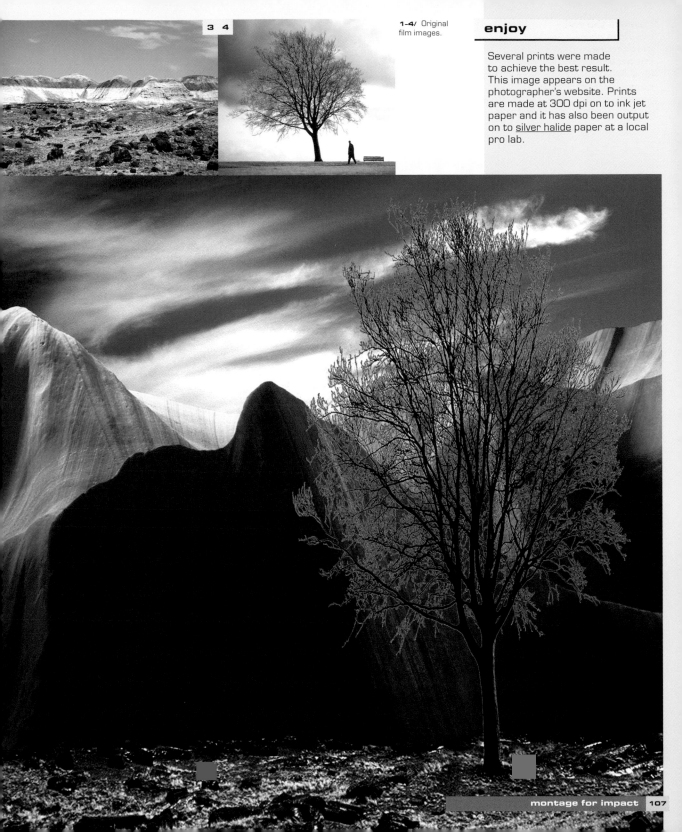

3 4

enjoy

Several prints were made to achieve the best result. This image appears on the photographer's website. Prints are made at 300 dpi on to ink jet paper and it has also been output on to <u>silver halide</u> paper at a local pro lab.

! Try using the freeform pen tool for more precise control when selecting around irregular shapes.

! Always save the various stages as you can retrace steps if anything goes wrong.

montage for impact 2

One of the beauties of photography is the flexibility it offers and with digital control this is virtually limitless. Here we take a look at an alternative way to create an image such as 'Canyon Sky Montage' from its component images. Which one do you prefer?

1 ✐ pen tool

Layers | Channels | **Paths**

Make Selection

Rendering

Feather Radius: 1 pixels
☑ Anti-aliased

OK
Cancel

Operation

⦿ New Selection
○ Add to Selection
○ Subtract from Selection
○ Intersect with Selection

2 layers

Layers | Channels | Paths

Normal | Opacity: | %

☐ Preserve Transparency

👁 Layer 1

👁 ✏ Background

3 layers > new layer

Layers | Channels | Paths

Normal | Opacity: 100 | %

☐ Preserve Transparency

👁 Layer 1

👁 ✏ Layer 2

👁 Background

4 layers > new layer

Image Layer Select Filter View Window Help

All ⌘A
Deselect ⌘D
Reselect ⇧⌘D
Inverse ⇧⌘I

Color Range...

Feather... ⌥⌘D
Modify ▶

Grow
Similar

Transform Selection

Load Selection...
Save Selection...

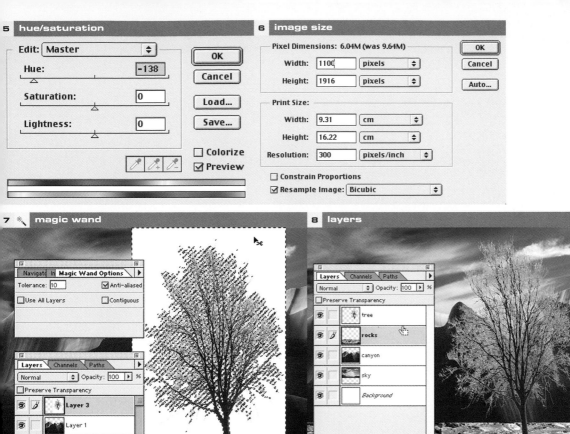

5 hue/saturation

Edit: **Master**

Hue: **-138**

Saturation: **0**

Lightness: **0**

☐ Colorize
☑ Preview

OK
Cancel
Load...
Save...

6 image size

Pixel Dimensions: 6.04M (was 9.64M)

Width: **1100** pixels
Height: **1916** pixels

Print Size:

Width: **9.31** cm
Height: **16.22** cm
Resolution: **300** pixels/inch

☐ Constrain Proportions
☑ Resample Image: Bicubic

OK
Cancel
Auto...

7 magic wand

Navigate | Magic Wand Options
Tolerance: 10 ☑ Anti-aliased
☐ Use All Layers ☐ Contiguous

Layers | Channels | Paths
Normal Opacity: 100 %
☐ Preserve Transparency
Layer 3
Layer 1
Layer 2
Background

8 layers

Layers | Channels | Paths
Normal Opacity: 100 %
☐ Preserve Transparency
tree
rocks
canyon
sky
Background

1/ A path like this is most effective when feathering and anti-aliasing are set.

2/ A new layer is used for the rotated rocks.

3/ The sky is pasted on to another layer.

4/ Sometimes it is easier to select the background then use select > inverse to get the object you are after.

5/ Basic adjustments to each layer.

6/ Tree height, but not width is changed through image size.

7/ Select the background with the magic wand tool, ready to cut out and leave the tree superimposed.

8/ The tree needed work on the pixel level before pasting into the montage. The image was flattened only after working on the ground and tree boundary.

enhance 2

While selections can be made in many ways, paths or clipping paths allow these to be saved for future use within the file, as here using Photoshop. Another advantage is that it is easy with a pen or shape tool to draw precise shapes.

After selecting a suitable tool, press the paths button. Draw around the desired area, in this case the canyon rocks, then save with a different name from the default 'work path' name. Clicking on the drop down menu for paths, choose make selection, with the feather and anti-aliased settings at values you want. It pays to experiment (1).

The rocks were then pasted into a new layer (2), with the sky area then selected from its original image and pasted behind the canyon as a further layer (3). Next the tree was added, but elongated first, through image size [Image > Image Size], with constrain proportions turned off so the width was not affected (6). Adjustments to each layer allow different areas to be improved through hue, saturation and brightness control (5). Hue and saturation turns fuzzy edges green, simulating leaves.

Selected by repeated use of the magic wand tool away from its background, the tree was cut and pasted into a new white background (7). Using the same tool, the background was selected, inverted [Select > Inverse], and the tree removed from the background (4). At this stage it was necessary to work at the pixel level to retouch where needed (8). The tree was placed on its own layer, with another for the ground area placed between the tree and rocks, with retouching to the ground and base of tree to complete the illusion. The image was then flattened [Layer > Flatten Image].

Digital imaging opens up vast scope for revitalising or re-creating film captured images. Now capturing with both digital and film SLRs, Walter Spaeth likes to see the world in terms of the colours and shapes presented.

new horizons

shoot

This image called 'Doves' results from photographs of three simpler pictures. These were a rapeseed field, the doves themselves and a sky image. All were shot on <u>100 ISO 35mm slide film</u> with a combination of 24–50mm and 70–210mm lenses.

1/2/3 The three images that made up the final image.

> 35mm film capture
> scan
> TIFF files
> photoshop
> duplicate layer
> hue/saturation
> PSD file > select all
> lasso tool
> paste
> move tool
> motion blur
> lasso tool
> paste
> brightness/contrast
> spherize
> flatten
> ink jet print
> giclee print

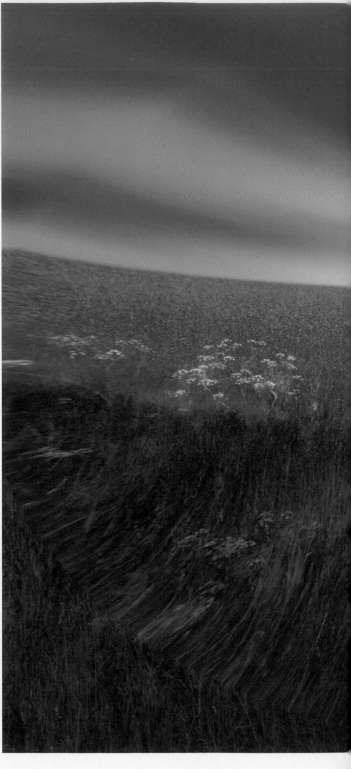

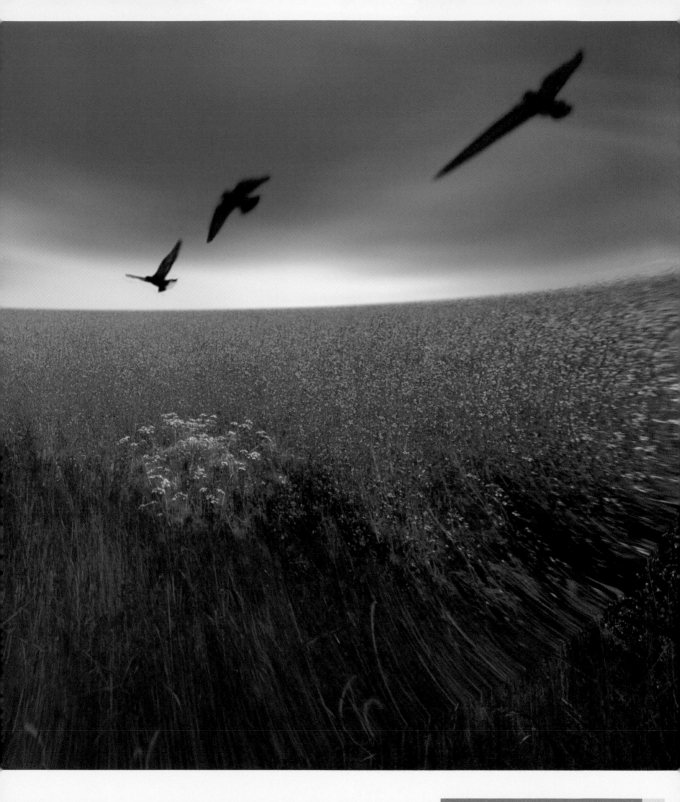

enhance

After scanning and converting into TIFF files, the images were opened into Photoshop. The rapeseed field was duplicated as a background layer (4), then adjusted in part for the desired effect (5) [Image > Adjustment > Hue/Saturation]. It was saved as a PSD file. Then the sky was selected from its own image using select all [Select > All] and copied. From within the copy, the lasso tool was used to cut and paste on to the rapeseed shot (6). It was adjusted for position via the move tool. Next, motion blur [Filter > Blur > Motion Blur] was added to the sky area (7). Then the doves were chosen with the lasso tool (8), and copied and pasted into the image. At this stage they were modified with brightness and contrast adjustment. The PSD file was flattened. The final touch was to spherize [Filter > Distort > Spherize] to create the impression of movement from a bird flying overhead.

! Giclee prints have appeal for those looking for archival qualities. They are produced by spurting ink in a continuous tone, using archival pigment not dye-based inks. Some recognise them as being suitable for 'fine art' sales due to their longevity.

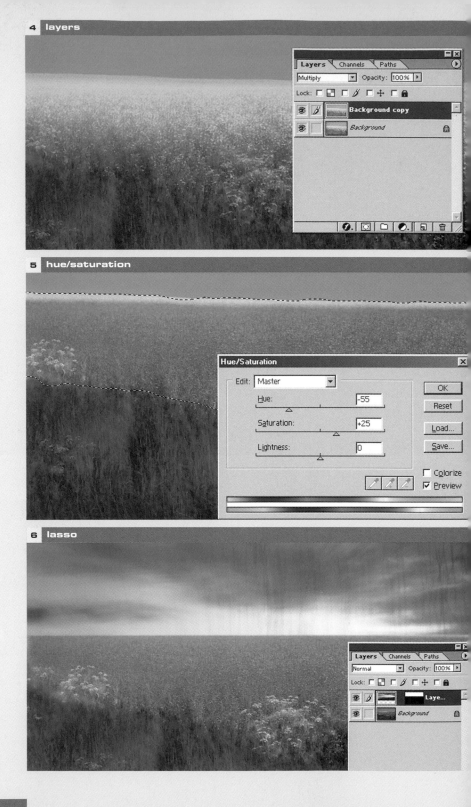

4 layers

5 hue/saturation

6 lasso

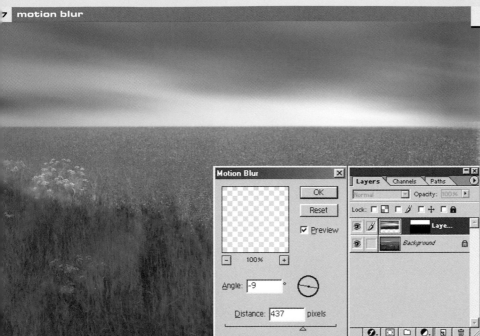

This has proved to be a really successful image. It has been produced as a limited edition of ten Giclee prints, made on Kupferbuetten paper at 60x40cm. A second limited edition of 30 was printed on an Epson 2000P printer for A3+ size images. Different finishes were tried, including watercolour paper from the printer manufacturer and high gloss paper (264g) from Tetenal. Add to that numerous exhibition appearances and success in photographic and digital imaging competitions.

4/ The original rapeseed image was duplicated ready for working on.

5/ Hue and saturation control gave the desired colour effect.

6/ The sky was cut and pasted via the lasso tool.

7/ The motion blur filter gave a feeling of movement in the sky.

8/ The doves were selected via the lasso tool.

9/ Brightness and contrast adjustment gave the doves the impact needed.

10/ The spherize filter gave the impression of a bird's-eye view over the scene.

'Try to transform your ideas, again and again.'

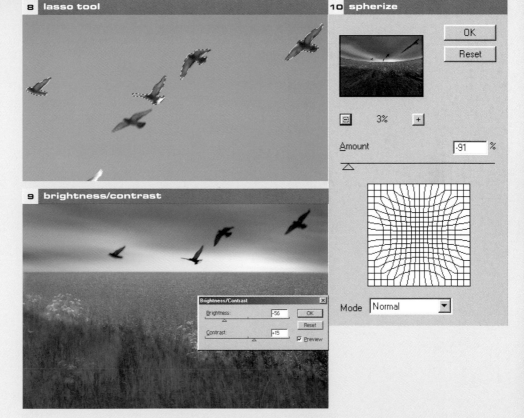

output

sharing the image

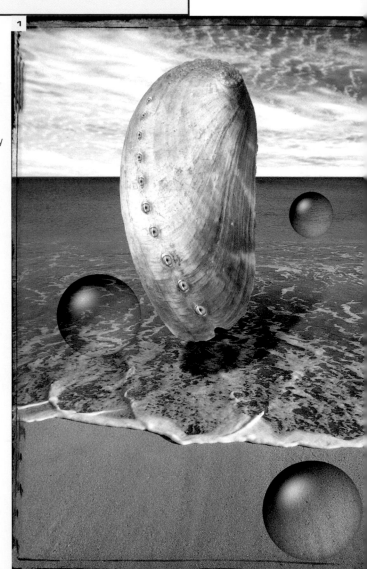

1

web images

How do you get the best image on the web? Likewise, that landscape which is ready to be put on to paper, framed and shown to the world. There are still some things to do to get the best results.

Small is beautiful for two reasons. First, it takes time to upload and download an image. This may be important, as parts of the world may not have fast broadband connection. Second, image quality needed to view on screen is not good enough for anyone to print or magnify, thus protecting your work. Features like <u>web photo gallery</u> in some versions of Photoshop help re-size images [File > Automate > Web Photo Gallery] and offer templates for the web.

! Be aware that most ink jet printers will convert your **RGB** image to **CMYK**, via an **sRGB** colour space. This can make matching colours difficult when working with another colour space.

! Deciding on the best result can be done by printing on numerous sheets of paper. But why not copy and paste the area you are interested in looking at with variations for the same area placed on a single sheet. This **test print** saves time and money.

! It is possible to output back on to conventional photographic paper. The image is supplied on disk, card or via the internet and converted at the processing lab usually to a near sRGB colour space, then to CMYK, so prints are made just as if from film. The traditional longevity, weight and quality is available. Set a minimum **300 dpi**, maybe more depending on your processing lab's printing machinery.

□ save for web

ink jet printing

The ink jet has changed the way photographers work. Some produce final images, others a 'proof'. As the name implies, a jet of ink from small nozzles is projected on to paper forming dots that overlap to give the desired colour. Use a printer with at least six inks if intending to get close to a near full tonal range, and it is best to use a seal and overlay and then frame results to improve longevity. Typically around 300 dpi is set for a 'photographic' look. Talking of 'look', watch out for metamarism; an effect where the inks look different under various light sources such as daylight, compared to household lighting. The spectral response changes depending on the illumination. It is best to judge prints for colour under the light they will be displayed.

web colour

Even though there are colours called 'web safe' this is no guarantee that what you see on your screen will look the same as someone else viewing theirs. For a start there are differences in the way that Apple Mac or PC systems use colour data, likewise between web browsers. While web-safe colours may help, it is ultimately best to view your web pages on both systems to gauge how they will look.

3 colour picker

1/ Paul Williams 'Glint' is a 21Mb TIFF file. But how do you change images for web use?

2/ Later versions of software manipulation programs offer easier to use and more flexible features for getting your images web ready.

3/ Web-safe colours (216) date from a time when computers were often limited to 256 screen colours. Such limitations are now rare.

appendix

glossary

glossary

Actions
A series of effects and adjustments made in a sequence, saving manual preparation each time they are needed, aiding the workflow when working on similar images.

Adobe 1998
A colour space for those needing a wider gamut than the more common sRGB standard.

Aliasing
Results in a jagged rather than straight or curved line. An anti-aliasing filter reduces the effect. Aliasing is also reduced in software by lowering the colour difference of edge pixels.

Analogue
A continuous signal of information. Whereas film is analogue, digital information is stepped.

Bit Depth
The term used to determine the gradations of tone or colour in an image. The higher the number, the greater the range. Most software manipulation packages work with eight-bit colour. If your capture device uses more, its range will be compressed to eight bit, but the extra information makes determining gradations more accurate especially in shadow areas.

Brightness/Contrast
A common adjustment needed for making images look there best. Maximum effect may come from working on specific parts of the image with differing amounts.

Canvas
As the name suggests it is the area of an image that can be worked upon. It is possible to adjust this to add to or take away in many software programs.

CCD
A Charged Coupled Device is the sensor unit found in many cameras and scanners. It usually makes use of red, green and blue light sensitivity.

Cloning Tool
A popular tool (also known as a rubber stamp) for pasting one area of an image on to another.

Colour Balance
Photographers often refer to a warm (orange to red) or cool (blue) looking result. Small amounts of either can be pleasing. When an image has neither it is called neutral. Most software options allow adjustments to be made.

Colour Picker
A means to select a desired colour.

Colour Space
The parameters for defining each colour within a device. Different Colour Spaces are referred to as having a wider or smaller gamut than an alternative. Ultimately the final use of an image determines what can be shown regardless of that used at capture.

Colour Temperature
Colour temperature is measured in degrees Kelvin (K). Human vision adapts to a range of temperatures so we perceive 'white light' under different light sources each with differing degrees K. A manual white balance measurement is the best way to capture the correct white point with a digital camera.

CMOS
The increasingly popular alternative to the CCD. A Complimentary Metal Oxide Semi Conductor as it develops may have some worthwhile advantages.

Curves
A capable method of adjusting the full or specific parts of a tonal range.

CMYK
An abbreviation for Cyan, Magenta, Yellow and Black. These are the colours commonly used in producing silver halide, ink jet and other forms of paper reproduction. 'K' represents black as a 'B' may otherwise be thought of as blue.

Feathering
A method with some selection tools to blur edge pixels thereby smoothing between areas.

File Format
There are different ways to store and interpret data called file formats. Choose with care depending on your use and working circumstance.

Filter
A means to enhance or modify all or part of an image by a physical attachment on camera or by a software adjustment.

Firewire
A popular connection for Pro level imaging equipment such as cameras and computer hard drives with relatively fast data transfer. It provides plug and play capabilities.

Gamut
The range of colours that can be printed or displayed.

Gradient Tool
A means to apply a transition of greyscale or colour to a specific area.

Grain
Component of film or software simulation. It is often useful with landscapes to add grain post-capture to give a photographic look to digital images.

Greyscale
A name for monochrome or a black, white and grey range of tones.

Healing Brush
A tool for cloning an image particularly useful in keeping tone and texture accurate.

Hue/Saturation
A common control for choosing and adjusting colour and its intensity.

Interpolation
The name given for adding new pixels to an image within software.

JPEG
A file format that uses selectable amounts of compression to make it relatively small to store and fast to transmit. It is an abbreviation for Joint Photographic Experts Group, a term for the collection of companies that developed it.

Lab Colour
A flexible means to work with colour and luminance. The latter is separated into its own channel with two others for colour. Either aspect can then be adjusted without affecting the others, unlike other common colour modes.

Layers
An effective means of working on parts of an image without changing the original as work progresses.

Levels
A simple means to change the tonal range of an image.

Pixel
A picture element, the building block of digital imaging.

RAW Data
The digital information generated before processing in a camera or dedicated software. It is a lossless and most flexible file format, taking up less space than a TIFF file. But it requires most time in post-production.

RGB
The use of sensitivity to red, green and blue for colour creation through them is common in digital equipment.

Silver Halide Print
A print made on to conventional photographic paper. It offers benefits of longevity if stored and displayed properly.

sRGB
The common default colour space for digital cameras and the nearest that can be shown in its entirety by a monitor. It has a small gamut compared to alternatives.

TIFF
Tagged Image File Format. A lossless file format. It creates a bigger size than a JPEG or RAW file, but can be read by most applications.

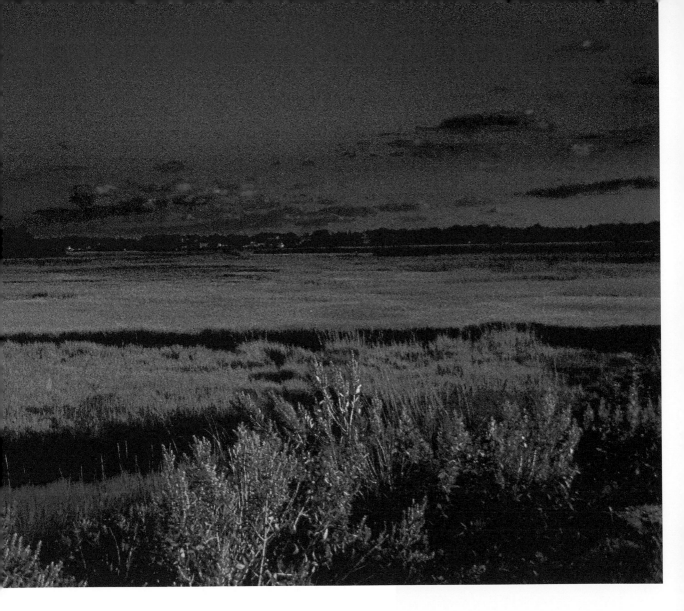

Tools

Undertaking specific jobs is done best using the most appropriate tool. For example the Magic Wand Tool is popular for making selections around parts of an image. Tools are often grouped together in a Tool Box.

USB

A common connection method between devices allowing plug and play operation.

USM

Unsharp Mask is fundamental when adjusting images. It will increase contrast between defined pixels improving the apparent sharpness. It may not be needed for photochemical reproduction as a printer will normally apply there own USM.

contacts

Ross Alford

Shooting with both film and digital cameras, the latter encourages Ross Alford to take plenty of images experimentally. There is a lot of post-capture exploration, with the initial shots often taken with a general effect in mind. Ross is based in Australia.

page: 80

http://homes.jcu.edu.au/~zlraa /photo.htm

Jeff Alu

A 3D artist and animator based in the USA, Jeff Alu spent time working in the traditional darkroom environment of the JPL/Palomar Observatory. After such an intense workload, he found digital had real appeal. His images have a depth that stems from his 3D design background, and often portray his chosen subject: deserts.

pages: 56, 96, 98

http://www.animalu.com/pics/ photos.htm

Hans Claesson

Living in Sweden, Hans Claesson's digitally captured images create impressions of the awesome force that is nature. He prefers the coastline as a subject. His work is used as part of exhibitions and sells as framed prints alongside online selling through stores and galleries.

pages: 54, 82

http://go.to/photonart

Norman Dodds

Living in the Scottish Borders, Norman Dodds describes himself as an enthusiastic amateur. Having embraced digital photography only in recent years, he now prefers to shoot with digital capture exclusively. The ability to preconceive how an image might be used after manipulation is important to him.

page: 32

http://home.freeuk.com/dunsps /fotozone/fotomenu.htm

Stephan Donnelly

Now an avid photographer, having picked up his first digital camera less than a year before capturing 'Eerie Sea', Stephan Donnelly had no prior photography experience. Since then he has devoted all his spare time to learning about photography, computers, and the intricacies of Photoshop. He is based in the USA.

page: 90

www.digitalphotocontest.com

Don Ellis

Based in Hong Kong, Don Ellis is an enthusiastic photographer with a passion for infrared photography using a digital camera. His philosophy is simple, 'I walk around with my eyes open – a human focal plane, as it were. When I see a pleasing combination of images, I photograph, sometimes obsessively because it's a moment in time that's not returning.'

page: 16

www.donellisphoto.com

 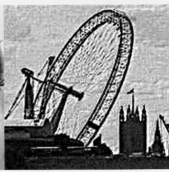

arry Berman

arry Berman describes himself
s a fine art photographer. A big
n of digital capture, he also
dvises about the subject
rough his website. A little
ystery surrounds his image in
is book as, like artists of
enturies past he likes to keep
ne exact details secret. He is
ased in the USA.

ages: 72

ttp://BermanGraphics.com

Jon Bower

As a full-time environmental
scientist based in the UK, Jon
Bower has been fortunate
enough to visit many parts of the
globe and create a wide range of
landscape photographs.
Shooting film originals, he draws
upon many digital techniques to
create his images.

page: 40

www.apexphotos.com

Leonard(us) van Bruggen

Van Bruggen is a self-taught
photographer. Having
experimented over the years
with techniques like multiple
exposures and Polaroid
transfers, the scope of digital
control was an obvious next step
for his silver halide imagery. Also
an artist, watercolours and
found objects are scanned and
used as backgrounds or
overlays for his work. He is
based in Canada.

page: 74

http://www.memorymarkers.ca

James Burke

A professional photographer
with a background in film and
darkroom work, James Burke,
based in Ireland, uses digital
cameras where immediate
client approval is needed and
film for less time-sensitive
work. Digital manipulation is
used widely regardless of the
capture method.

page: 62

www.grand-design.co.uk

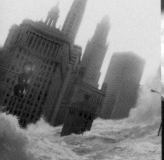

homas Herbrich

ased in Germany, Thomas
erbrich uses all the skills of a
rofessional, commercial
hotographer. Comfortable
hooting in a range of film
ormats, his landscapes are
enerally taken on medium
ormat. Digital manipulation
llows visually striking results,
ften combining unexpected
omponents.

ages: 84, 102, 104

ww.herbrich.com

Tony Howell

A UK-based photographer, Tony
Howell likes to create montage
images – those that have
something familiar but also
surreal. Digital imaging is the
key, with his original images
captured often on medium
format film. Then comes his
acquired software skills.

page: 106

www.tonyhowell.co.uk

Gary L Kratkiewicz

As a keen enthusiast Gary L
Kratkiewicz often enters his
images in online photo
competitions. Some are also
shown in local exhibitions.
Making full use of the benefits of
digital capture he is rarely
without a camera. Gary is based
in the USA.

page: 78

**http://www.pbase.com/
kratkiewicz**

Daniel Lai

Currently living in the USA,
Daniel Lai is a fine art
photographer who captures with
both digital and silver halide
cameras. His work sells from his
website and is published in
photographic magazines, plus
online workshops. Digital
imaging enables otherwise
ordinary images to be turned
into shots with impact through
his skills with Photoshop.

page: 52

www.danielart.com

Henri Lamiraux

Based in the USA and very much a 'digital' photographer, Henri Lamiraux utilises a solid workflow as key to the success of his images. They are captured, manipulated and archived in a logical sequence that maintains quality throughout. He uses numerous software packages, not just for the sake of it but for specific things they bring to the way he wants to work.

page: 48

http://www.realside.com

Frank Lemire

Frank Lemire is a Canadian photographer who has developed a passion for capturing images with a digital camera using its infrared sensitivity with suitable on-camera filtration. Much of his photographic work centres on trees.

page: 36

www.abstrakt.org

George Mallis

George Mallis is based in the USA. His work is used in numerous ways including its place in some private collections. His imagery shows a wonderful mix of reality, combined with advanced digital imaging techniques, producing the final artistic effect.

pages: 42, 92, 123

www.georgemallis.com

Steve Marley

Steve Marley has stopped shooting film and taken to using high quality 35mm style digital capture. Based in the UK, most of the images he sells are action based, but his cityscapes make an interesting part of his growing portfolio. His work shows that digital imaging does not have to mean 'surreal'.

pages: 34, 50, 64

Allan Schapp

Allan first started to work digitally quite recently. He is a semi professional photographer who resides in the Netherlands. Although he has a photographer's training, he considers himself a 'photographic artist'. Often the balance of colours help make the image work, starting from a simple composition.

pages: 4, 26, 67

Carl Schofield

Based in the USA, Carl Schofield is an enthusiast who shoots images for competitions and for sale in galleries. Having converted to digital photography some years ago, he likes to shoot a lot of imagery in infrared, with post-capture enhancement bringing out the desired effect.

pages: 100, 102

http://home.twcny.rr.com/ scho/newpics/intro.html

Walter Spaeth

A multi award-winning photographer, Walter Spaeth learned traditional darkroom methods, but was an early convert to the benefits of digital imaging just when it was starting to get interesting. He creates striking imagery combining colour, light and form, to combine a reality with something less conventional. He is based in Germany.

pages: cover, 110

www.artside.de

Frantisek Staud

Frantisek Staud uses traditional and digital methods to produce his images. This means capturing with 35mm slide film, then drum scanning for ultimate quality, or using a pro level desktop model. Photoshop then comes into its own before outputting on to either ink jet or laser prints. Based in the Czech Republic, his submissions to publishers, magazines and photo libraries are all in digital form as people no longer ask him to send film originals.

pages: 12, 25

Mike McDonald

Mike McDonald from the USA makes pictures for his own enjoyment. He now uses digital capture rather than film cameras, as this suits his particular image needs best. His results are frequently exhibited on the internet, where he regularly wins 'Photo of the day' awards.

page: 76

www.digitalphotocontest.com

Dave Newbould

Using a camera initially in order to record his mountaineering experiences, Dave Newbould was surprised to find that his images were appreciated by others. In 1993 he started up his company, 'Origins', which produces cards, posters and calendars. His work in this book shows the results of high quality scanning to 'digitise' his images. He lives in Snowdonia, Wales.

pages: 6, 35, 94, 114, 118

www.davenewbould.co.uk

Bob Reed

A fine art photographer, Bob Reed has used mostly large format film cameras. Post capture digital control is opening up new possibilities, even for those images shot before he mastered Photoshop. Big enlargements are made, framed and sold through shops, galleries, interior decorators, his website and studio, as well as corporate art consultants. Bob is based in the US.

pages: 20, 46, 58

www.AlpineImages.com

Ron Reznick

Ron Reznick is a photographer who has embraced digital capture wholeheartedly. Getting the best in-camera exposure is the key to his philosophy. Having spent time mastering various software programs his post production processing is now kept to a minimum. Ron is from the USA.

page: 14

http://www.digital-images.net/

Olga Svibilsky

Originally from the Ukraine, Olga moved to the USA in recent years. Using compact and SLR digital cameras, she appreciates that Photoshop gives unlimited possibilities for digital manipulation, allowing her to follow her passion of photography to the full. Images are used on a number of websites.

page: 120

www.princetonol.com/groups/photoclub/OlgaSergyeyevaPhoto gallery/index.html

Maarten Udema

The Netherlands is where Maarten hails from. His landscapes take in numerous parts of the world and are shot on various film formats. These are then combined with his digital imaging skills to create striking results, but with a sense of believability to them.

page: 28

http://www.mauph.com

Steve Vit

Having no formal photographic training, it was travelling around the world in 2000 that proved the catalyst for taking up digital photography. With his strong interest in computers, Steve Vit's photography has developed largely as part of the net-based digital photography community. He lives in Australia.

page: 44

www.digitalphotocontest.com

Paul Williams

The work of Paul Williams makes use of advanced software techniques to create meaning from multiple film originals. His photography is sold as limited edition prints through art galleries in England and also through his online gallery. There is sometimes a hidden 'message' about environmental impact to some of his work. Many hours post-capture are spent creating the desired result.

pages: 10, 86, 116

www.photocornwall.com

acknowledgements

Any book is the result of a team effort. A big thank you to Kate Stephens for her patience and guidance throughout, Natalia Price-Cabrera for her editing and Sarah Jameson for intensive picture research. To Bruce Aiken for his design and insight, and Brian Morris for his helpful suggestions as we progressed. Finally, with photographers around the world contributing, a special thanks goes to them for being so helpful with our needs, not just for pictures, but background information too.